# SECRET PORTSMOUTH

## Steve Wallis

AMBERLEY

First published 2016

Amberley Publishing
The Hill, Stroud
Gloucestershire, GL5 4EP

www.amberley-books.com

The right of Steve Wallis to be identified as the
Author of this work has been asserted in accordance
with the Copyrights, Designs and Patents Act 1988.

ISBN  978 1 4456 5516 1 (print)
ISBN  978 1 4456 5517 8 (ebook)

British Library Cataloguing in Publication Data.
A catalogue record for this book is available from the
British Library.

Typesetting by Amberley Publishing.
Printed in Great Britain.

# Contents

# Introduction

Portsmouth is unique in many ways. It is Britain's only island city and is also the most heavily fortified. Packed onto Portsea Island, and with its views inland blocked by the mass of Portsdown Hill and its Victorian forts, it is natural that the place has often seen itself as separate from the rest of the county – Portsmouth has developed its own very special identity.

Its location means that Portsmouth has always looked to the sea and, when we think of the city's history, it is the naval connections that naturally come to mind. This book looks at some of Portsmouth's lesser-known links with the navy, as well as with other seafaring matters. In common with other subjects covered, the aim is to pick out things that are not well known already.

Portsmouth Harbour has been of vital importance to the expansion of the city, but the earliest strongpoint on the harbour was Portchester. The location at the mouth of the harbour became more attractive as parts silted up and a town was founded here in the twelfth century. Though ideally located for maritime trade, Portsmouth's development was hindered by French raiding over the next few centuries, which led to further fortification of the town. The naval presence was also growing, so that it became the country's chief naval port, with many and continuing associations. In the eighteenth century, the town began to expand beyond its defensive walls and, in a process that continues today, it engulfed the farms and hamlets of Portsea Island before expanding onto the mainland during the twentieth century.

Nowadays, of course, Portsmouth covers the whole of Portsea Island and part of the adjacent mainland, so it can be difficult to envisage that, until relatively recently, 'Portsmouth' meant only a place in the south-west corner of the island and that the city's modern suburbs, such as Fratton and Hilsea, were once separate settlements. Portsmouth's expansion beyond the walls of 'Old Portsmouth' is an important element in its history.

This book looks at other matters as well as 'straightforward' history. Portsmouth has had many literary associations and some of the less familiar aspects of these matters are also examined – for instance, Portsmouth is renowned as Charles Dickens' birthplace, but he also set part of one of his best-known novels here, within which is a hilarious parody of a theatrical performance.

Other chapters consider, in the same fashion, some of the famous people who have lived in and visited the city, the criminal activities that took place and also some of the more unusual features of the lives of the many people who have lived, worked and played in 'Pompey'.

Generally, I have kept to subjects within the boundary of Portsmouth borough, though with one or two exceptions – notably Portchester because it was effectively Portsmouth's predecessor.

When researching this book, I found a great deal of fascinating information about Portsmouth, its history and character, and have aimed at including things that the general, local reader may not know. I hope I can pass on the pleasure of finding out these things and hunting down the places in this book. Portsmouth certainly is an excellent place to explore; it can also be very rewarding to look closer at what you pass at all times.

# 1. History

## Before Portsmouth

In the third century, much of Britain was a relatively peaceful province of the Roman Empire. One significant problem was coastal raiding by people from outside the empire, mostly from what is now Germany and Holland, and so a series of forts were built along the south and east coasts to serve as bases for a fleet that combated the raiders. The modern term for these is the Saxon Shore forts and one of them was constructed at what is now Portchester. Its name was probably Portus Adurni and its remains are the best preserved Roman fort in Northern Europe.

Though the fort went out of use around the time of the end of Roman administration in Britain in the fifth century, it was reused later on, firstly as a high-status dwelling in late Saxon times and then, soon after the Norman Conquest, a castle was built in one corner.

Around this time, Portsea Island was sparsely populated. The Domesday Book of 1086 recorded just thirty-one men on the whole island – they would generally have had families of course, so it would probably be accurate to say there was around thirty-one households.

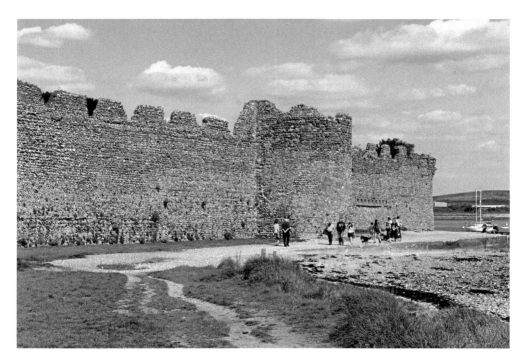

The south side of Portchester Castle, from the harbourside footpath.

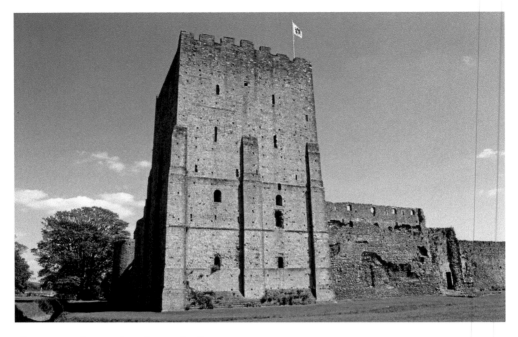

The Norman keep at Portchester Castle.

## DID YOU KNOW?

It is sometimes stated that Portsmouth has been the home of the navy since AD 897 when King Alfred's fleet defeated a Danish one here. The battle would have been fought in Portsmouth Harbour not in the town, which did not exist at the time.

## The Origins of Portsmouth

In the twelfth century, it was becoming increasingly difficult to reach Portchester, presumably because the upper parts of Portsmouth Harbour were silting up and the suitability of the area near the harbour mouth on the Portsea Island side was recognised. A Norman landowner called Jean de Gisors founded a town at Portsmouth in 1180, with a port area at the location now known as the Camber. Fourteen years later, he fell foul of Richard the Lionheart for supporting the king's brother John in an attempt to usurp the throne and had to hand over his lands, including the new town. Richard gave the town its first charter on 2 May 1194 in return for money to fund his overseas wars, and apparently had houses built here for royal use. Richard left England the same year with the money he had raised from the country and, though he lived for five more years, he did not return.

On Richard's death, his brother John became king and, in 1212, John ordered that a protective wall should be constructed around what had become a royal dockyard at

Portsmouth's first port.

Portsmouth. It is ironic that John was now controlling a harbour that Jean de Gisors had lost for supporting him.

The location of this first dockyard is rather surprising. It was centred in St George's Square, the area behind Gunwharf Quays in front of the Shipwrights' church, and is a reminder of how much land has been reclaimed from the harbour hereabouts. In the time of King John, all of the area now occupied by Gunwharf Quays would have been underwater.

We tend to think that England has not been invaded successfully since the Norman Conquest in 1066 and that conflicts with foreign armies have taken place on other countries' soil. This is not quite the case, and an example that sometimes has been glossed over is French raiding on the English coast during the Middle Ages. Portsmouth was one of the most vulnerable locations and suffered particularly badly in 1338, about a year into the Hundred Years War with France, when a raiding party set the town on fire, destroying all the buildings except the parish church and the hospital of St Nicholas.

A recent image of
St George's Square.

Later in that conflict, Portsmouth Harbour was one of three locations in Hampshire where Henry V mustered his forces before sailing to France for the campaign that resulted in the major victory at Agincourt in 1415. The king himself set sail from Portchester Castle, following an assassination attempt on him at Southampton led by the Earl of Cambridge.

During the reign of Henry VII, construction of a new royal dockyard began in 1495 on a site separated from Portsmouth by what was then Portsmouth Common. This did wonders for the economy of Portsmouth, as not only would local people have been employed in the construction, but once the docks were completed there was a need for what today would be called 'support services' to supply the needs of sailors and others who worked at the docks. When fortifications were built around both the dockyard and the town around the middle of the sixteenth century, again there must have been lots of employment opportunities.

## The Civil War and Afterwards

Early in the Civil War of the 1640s between Charles I and Parliament, Portsmouth's port was recognised as strategically important for naval operations and the movement of supplies. In 1641, the governor of the town, George Goring, convinced both sides he was with them and started work on improving the fortifications. Then on 2 August 1642, he declared for the king and a Parliamentarian siege from land and sea began around a week later. The opposition's rapid appearance probably took Goring by surprise; the town's defences were not ready and there were such limited stores of food that Goring's men had to raid farms around Portsea Island very quickly when Parliament's land forces appeared on Portsdown Hill. After various skirmishes, the Parliamentarians captured Southsea Castle on 4 September, which forced those inside Portsmouth itself to negotiate. They were given safe passage on 7 September, one of the reasons for this being that they had agreed to hand over the gunpowder held in the Square Tower and elsewhere – they had threatened to blow it all up. Goring continued to play an important part for the Royalists later in the war, though he tended to be self-serving and sometimes negligent.

### DID YOU KNOW?

Monks of the Augustinian Order founded a monastery within the walls of Portchester Castle in 1133, though twenty years later they moved to the new site of Southwick Priory a few miles inland. A castle may seem an odd choice, but there would have been plenty of people here in need of care and it wasn't a bad place in times of trouble.

Portsmouth was effectively a garrison town during the seventeenth century, which meant there were lots of soldiers that needed accommodation. The usual practice was to billet them in inns and private houses, which does not sound too bad until you read of a mayor of Portsmouth having over twenty men staying with him in 1665. The solution was a separate building and, in 1695, Colewort Barracks came into operation. It had been built in 1680 as a

military hospital and was in what is now Highbury Street that runs roughly north off the High Street in Old Portsmouth – this was originally called Colewort Garden Street. *Colewort* is an old name for cabbage and there seems to have been a garden here in the Middle Ages belonging to a monastic establishment. The barracks was in use into the early twentieth century.

## The City of Portsmouth

To leap forward to more modern times, one matter in particular needs to be mentioned here. After much distinguished service to the nation, Portsmouth finally became a city in 1926, although it had to complain first for this to happen. Several other cities had been given the status in the years following the Second World War and Portsmouth felt it has as good a case, or better, than any of them. Linked to this grant, the parish church became a cathedral in 1927.

### DID YOU KNOW?

The Borough Arms of Portsmouth, which you see adorning all sorts of municipal structures around the city, are thought to date from the time of Richard the Lionheart. The arms show a star above a crescent moon (on a blue background when depicted in colour), described in the technical terms of heraldry as 'Azure a star between the horns of a crescent or'. This is similar to the arms of Richard II, so the new town may well have adopted those of its benefactor.

The Borough Arms on an ornamental bollard in Southsea.

# 2. Naval and Other Maritime Matters

## The Mary Rose

One of Portsmouth's icons is the *Mary Rose*, which is displayed in Portsmouth Historic Dockyard following its raising from the seabed in 1982. The story of its sinking in July 1545 is an interesting one, not least in that it took place during an attempted invasion by the French who were still confident enough to attempt this 200 years after burning Portsmouth. This was late in the reign of Henry VIII, during the last of several wars with France that he engaged in. The French invasion force had been able to enter the Solent Channel unopposed and even to land troops on the Isle of Wight and the coast of Sussex; those on the island were defeated in battle but those on the mainland stayed several weeks. Though they left without achieving much, they were not forced out. In what became known as the Battle of the Solent, the outnumbered English fleet engaged the French on 18 and 19 July and, on the second day, the king's flagship was lost. Contemporary accounts and modern investigations suggest the most likely reason for this was that the *Mary Rose*'s crew left the gun ports open after firing at the French and then, when the ship turned during a gust of wind, water came into the vessel. It could be added that various alterations made to the ship during its thirty-plus years of service probably had made it unseaworthy. Less than thirty-five out of a crew of around 400 survived.

A little-known fact to record about the *Mary Rose* is its first rediscovery. The second took place in 1970–71 and led to the initiative to raise the vessel, but the first was in 1836, after fishermen reported catching their nets on it. Professional divers visited the wreck, salvaging some looser items and even using explosives to get inside the hull, though much of the vessel was too deeply buried under the seabed for them to explore it completely.

## The Hard

The Hard is the area to the south of the Historic Dockyard. Although the name is sometimes applied to the road here, the original Hard was a landing area for ships. It was literally a hard surface up which boats also could be hauled for repairs. It was constructed from ballast, the heavy material that a sailing vessel returning empty to its port would need to hold itself steady in the water. Since, on its return, the vessel would fill itself with cargo, the ballast was now superfluous. Different dates around 1710–20 are given for the construction, perhaps reflecting that this was a gradual process with more material being added every time a ship came in. Its name is sometimes given as the Common Hard, presumably to mean that it was intended for the use of all non-military vessels coming into Portsmouth.

## A Hero of the First World War

Down in Southsea, not far from Canoe Lake, there is a blue plaque on No. 12 Helena Road that commemorates a distinguished former occupant. Edwin Unwin (1864–1950)

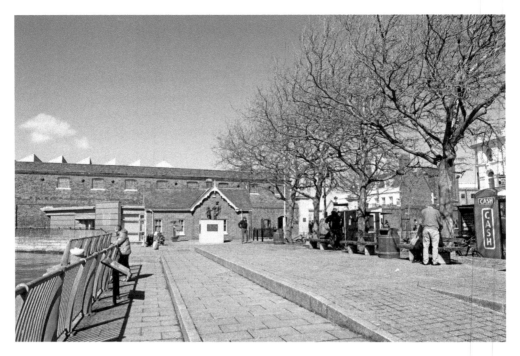

The Hard in modern times.

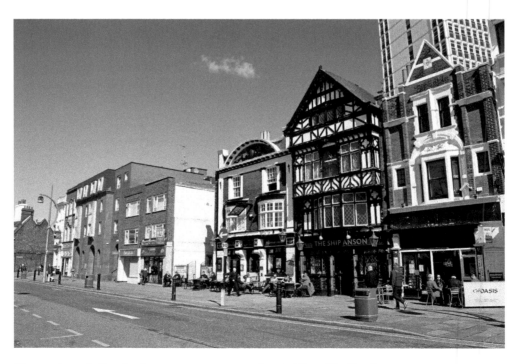

Many pubs and other businesses grew up across the road from The Hard.

had retired from the Royal Navy in 1903 having attained the rank of Commander. Like others who had retired from the military, he was recalled to his former service after the outbreak of the First World War. In spring 1915, when the Western Front was clearly in a stalemate, the British attempted to divert the Germans through an attack on their ally, Turkey. The Expeditionary Force that landed on the Gallipoli Peninsula in that country encountered more resistance than expected, became bogged down and eventually withdrew.

Unwin was in command of one of the troop-carrying ships, SS *River Clyde*, which he adapted to allow the quick disembarkation of those men. During the actual landing at Gallipoli, many of the vessels involved became caught on barbed wire defences and the British were surprised by heavy machine-gun fire from the Turkish forces. Unwin was at the forefront of securing the vessels so that the troops could land and, despite having to be treated for bullet wounds onboard the ship, went back to rescue wounded soldiers.

He was awarded the Victoria Cross, the highest of Britain's military honours, for these actions. Unwin survived the war and then retired a second time in 1919, having reached the rank of commodore.

## A Maritime Oddity

If you stand at the end of Ferry Road, just before the ferry itself, and look north-east across the main channel, you see an unusual structure next to Sinah Sands, the sandbank on the Hayling Island side of that channel. At first glance, it looks like it was placed there to protect the harbour, maybe when the tank traps were being erected, but its origin is rather different. During the Second World War when the Allies were planning the Normandy landings that were to take place in June 1944, they realised the beaches they were to use could not cope with all the heavy vehicles involved. The solution was the construction of Mulberry harbours that could be towed across the English Channel to do this job. Phoenix cassions were lengths of concrete watertight chambers used in the construction of Mulberry harbours and, when a crack was noticed in one cassion that made it useless, it was dumped here.

The Mulberry caisson, near the entrance to Langstone Harbour.

## Cold War Intrigue

A local incident connected with the Cold War, which followed the Second World War, is the disappearance of the diver Lionel 'Buster' Crabb in Portsmouth Harbour. His nickname came from the American Olympic swimmer and actor Buster Crabbe (perhaps best known as Flash Gordon in the 1930s series). Lionel joined the Royal Navy during the Second World War and became a diver and saw distinguished service in the Mediterranean. After the war, he continued working as a diver in civilian and military roles and, in 1956, he was recruited by MI6, the intelligence agency dealing with foreign matters. In April of that year, he dived to investigate a Soviet cruiser called the *Ordzhonikidze*, which was visiting Portsmouth and disappeared. A body in a frogman's suit washed up in Chichester Harbour fourteen months later and was eventually identified as Crabb. Exactly what happened is still unknown, but this being the stuff that spy novels are made of, plenty of accounts of what happened during and after Crabb's mission have been written. These generally state that he was captured by the Russians and perhaps killed deliberately, but it is also possible that he simply died in an accident.

### DID YOU KNOW?

An original approach was taken locally to commemorate a more recent conflict in the Falkland Islands in spring 1982. Images of the triumphant return of warships to Portsmouth after the conflict with Argentina over the South Atlantic islands are still remembered nationally, and on Portsdown Hill there is a memorial to the 258 British service personnel and Falkland Islanders who lost their lives. Close to the large car park and viewing point near Fort Widley, a plantation of 258 beech trees was planted, which today has grown into a wood that makes for a cooling stroll on a hot day.

The Falklands Memorial Plantation on Portsdown Hill.

# 3. The Military on Land

When thinking of the military in Portsmouth, it is the navy that first comes to mind. However, the army also has been of great importance to the city. For one thing, if the enemy was somewhere further along the coast, they were needed to defend the dockyards from attack overland.

## Southsea Castle
Southsea Castle's construction is the first recorded use of the name. It was built in just six months during 1544 and, in accordance with the latest military thinking, incorporated gun platforms located to fire in all directions within a building that provided as small a target as possible for enemy guns. Also, the marshy ground around here that was later to become Southsea Common, made attack from the landward side difficult. The building of the castle was not an isolated incident, rather it fits in with the politics of the time. In the early 1530s, Henry VIII had declared himself Head of the English Church, which not only led to conflict with the Pope but also Catholic France and Spain. Another action of Henry's later in the decade, the Dissolution of the Monasteries, further alienated his opponents on the Continent, but also helped in his defence against any resulting invasion. By declaring himself head of the Church, the monasteries and their extensive lands and other wealth were, in Henry's view at least, his to sell. Thus, the sale of these assets, often to Henry's cronies at rather knock-down prices, provided the funds to build a series of defensive forts along the South Coast, of which Southsea was one. In many cases, stone from monastic buildings was reused in the forts, saving the expense of quarrying.

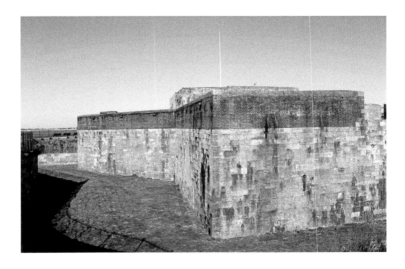

Southsea Castle.

## DID YOU KNOW?

One thing you may not notice if you are casually pottering along the esplanade is that Southsea Castle is at the southernmost point of Portsea Island – one good reason for the lighthouse being built here.

The strategically important position of the castle, commanding the entrance to Portsmouth Harbour, meant that it remained important for several hundred years and was updated in various ways over that time. It has had other uses; at one time it was a military prison, in the 1820s the lighthouse that is still in use was constructed here, and of course today it has become one of Southsea's main tourist attractions.

### Lumps Fort

Off to the east of Southsea Castle, beyond South Parade Pier and Canoe Lake, we find Lumps Fort. It was built for coastal defence in the late eighteenth century and, for a time in the early nineteenth century, it was used as a semaphore station – otherwise, it fell into disrepair. It was reused as one of the Palmerston Forts in the 1850s (more about these shortly) and refurbished again for coastal defence in the First World War. At the end of that conflict much of it was demolished, although it looks as though a pillbox was built on it during the Second World War. Today, Southsea Rose Garden lies within its old fortifications and Southsea Model Village is at one end towards Canoe Lake.

Pottering around the remains of the fort today, it is easy to imagine that the name 'Lumps' comes from the shape of its defences. In fact, the name predates the fort, and actually comes from a family name. A short way inland there was a Lumps Farm in the seventeenth century or earlier and one Ralph Lumps was a landowner here. Old maps

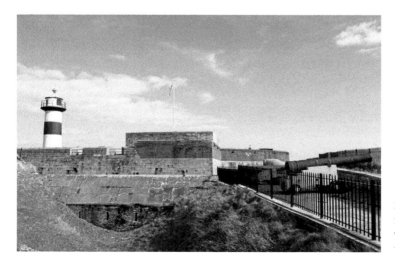

Part of Southsea Castle from the west side, with the lighthouse on the left.

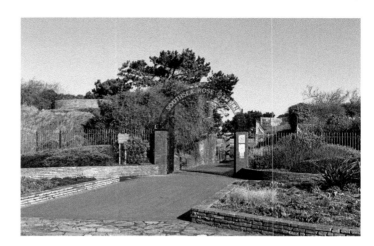

The entrance to Southsea Rose Garden through the defences of Lumps Fort, with the pillbox at the upper left.

## DID YOU KNOW?

In the eighteenth century, Fort Cumberland was constructed on the southeast shore of Potsea Island to protect both Portsmouth and Langstone Harbours. Despite the use of convicts to do the labouring, the expense and effort were still questioned. The contemporary historian Edward Gibbon expressed his views on the matter thus:

To raise this bulwark at enormous price,
The head of folly used the hand of vice.

also show a Lumps Mill nearby, and Eastern Villas Road a short distance to the west was once called Lumps Lane.

## Defending the Island

A good example of the value of the army in supporting the navy is the defence of Portsea Island itself: if an enemy landed elsewhere on the South Coast and wanted to attack the fleet at Portsmouth, Ports Creek was a good place to stop them. The earliest defences by Ports Creek date from 1544 when Southsea Castle was being built – these were on the mainland side of the creek.

The first defences on the Portsea side were constructed in the 1750s, during a period of war with France. Hilsea Barracks were built in 1756 initially as temporary accommodation for the soldiers working on the construction (their later uses included accommodating soldiers wounded in the Battle of Waterloo in 1815 and they were not finally closed until 1962).

The defences that we largely see today, albeit somewhat overgrown, were constructed between 1858 and 1871. They are around 1.5 miles or 2.5 kilometres in length. The bank is nearly 30 feet high and 60 feet wide and has six bastions.

A view from the western end of Hilsea Lines showing the tree-covered earth banks and part of what is called the Seawater Moat.

The Freshwater Moat of Hilsea Lines.

## An Undeserved Nickname

On a clear day at least, no visitor to Portsmouth can miss the series of massive red-brick forts on Portsdown Hill that were built in the 1860s. In order, from the west, they are Forts Wellington, Nelson, Southwick, Widley and Purbrook, then Farlington Redoubt. The first two were named after heroes of the Napoleonic War, and the others after nearby villages.

They are often called Palmerston's Follies after the prime minister who instigated their construction and because they were never used and had guns facing inland. A similar group of forts above Plymouth bears the same nickname.

Palmerston needs defending from this. The politics of the time meant that invasion from France was seen as a clear threat, and Palmerston did not make his decision to fortify Portsmouth and other vulnerable locations alone – he was advised to do so by a Royal Commission in 1859. The guns facing inland are easily explained: there were other installations defending Portsmouth against an attack from the sea and the forts were designed to repel attackers who had landed elsewhere on the coast and were approaching Portsmouth from the north. Finally, it might be argued that the fact that the defences were never used testifies to their value as a deterrent.

The fortifications intending to protect Portsmouth extended over a wide area (many were on the Gosport side of Portsmouth Harbour, for example). Although the final phase of Hilsea Lines was being built at the same time, this was not part of the same plan – the scheme put forward by the Royal Commission and advances in military technology made the lines rather obsolete even before they were finished.

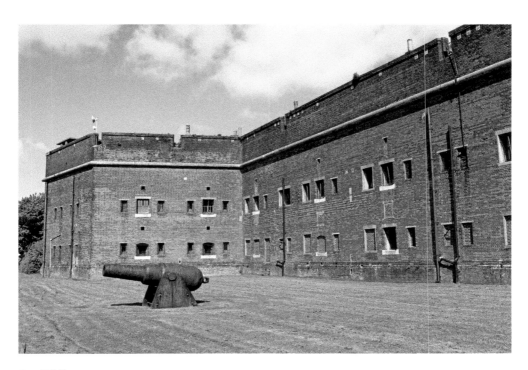

Fort Widley.

## DID YOU KNOW?

If you go to the area around Clarence Pier on the esplanade and look across towards the Isle of Wight, Spitsand Fort is the closest to you, with No Man's Land Fort almost directly beyond it. The one off to the left is Horse Sand Fort. St Helen's Fort is just off the Isle of Wight's east coast and is difficult to make out.

The most unusual survivals of the Palmerston scheme are the forts in the Solent. To construct what are effectively dry-land installations in the sea took tremendous effort. These four forts, three of which are clearly visible from the esplanade, defended not just Portsmouth but the whole eastern approach into the Solent. Work did not start until 1865 and the four forts were not finished until 1880 when the danger of French invasion was long past. For their foundations, stone blocks had to be taken out to sea on barges and then manoeuvred into place by divers – a great deal of effort before the 'normal' building of a fort could take place.

### Another First World War Hero

A local hero of the First World War was Sergeant James Ockendon (1890–1966), who was born in Landport. In Belgium in 1917, he led his men to capture an enemy machine gun and a barn full of soldiers, for which action he was awarded the Belgian Croix de Guerre and, like Commander Unwin, the Victoria Cross. On his return to Portsmouth,

Spitsand Fort with Ryde on the Isle of Wight to the left.

he was given a hero's reception and the City Council later named Ockendon Close in Southsea in his honour – it is on the north side of Elm Grove. He was a crane driver in the dockyard after the First World War and he spent the rest of his life in the city.

## Invasion Defences and their Re-use

Following the withdrawal from Dunkirk in May and June 1940, there was a period of genuine fear of invasion. Plans for defending the country against an invading German army were rapidly drawn up and infrastructure for this was constructed, also with great speed. Much of the South Coast was seen as vulnerable to attack and Portsea Island was no exception. The island's coastline was blocked off with barbed wire and tank traps (concrete blocks intended to block routes that tanks might use) and pillboxes were built for the defending forces. The defences made days on the beach an impossibility.

You can see still see evidence of these defences here and there today. Perhaps the best place is around the road to the Hayling Island ferry, where tank traps are still scattered on the beach, while a line of them have been moved to one section of roadside to prevent people from parking on the verge.

The beach at the entrance to Langstone Harbour with Second World War concrete blocks.

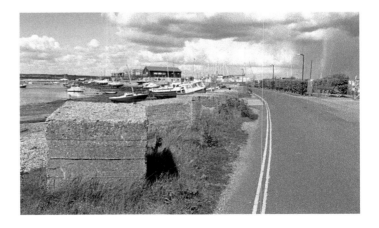

Tank traps being recycled.

Another one of these blocks can be seen across the road from South Parade Pier a short distance in the direction of Canoe Lake. One side has the date 1940 followed by the words 'France and the Low Countries having been overrun we laboured alone to obstruct our coast with such blocks as this against invasion by the enemies of freedom.' Another side has an inscription with the date 1944, recording that thousands of Allied troops left to liberate Europe 'from this very beach' – these last words indicated that it is not in the exact spot where it was originally set up as a memorial.

## Fooling the Enemy

To alleviate the impact of bombing during the Second World War, an ingenious system was devised to fool enemy aircrews into dropping their bombs where they could do relatively little damage. One of these 'Starfish' sites, as they were known, was designed to protect Portsmouth. A series of fires would be lit across Farlington Marshes, parts of Hayling Island and on the small islands in Langstone Harbour to give the impression that here was a city already under attack. Other structures were lit up, which looked like light coming through the chinks in the blackout curtains that were supposed to keep a city dark. This worked spectacularly well on the night of 17–18 April 1941 when 200 bombs that were intended for Portsmouth were dropped in this decoy area instead. You pass one of the control shelters for this system (it looks like a large brick box) as you come into Farlington Marshes nature reserve from the car parks at the north-west corner.

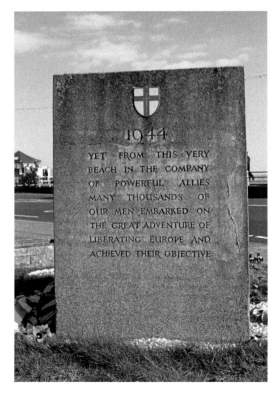

The tank trap memorial.

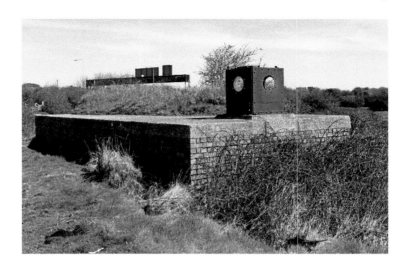

'Starfish' control bunker at Farlington Marshes.

## DID YOU KNOW?

The importance of Field Marshal Bernard Montgomery in the Second World War is rightly celebrated. His victory over Rommel's forces at El Alamein and his command of the British forces in the Normandy landings and subsequent campaign across Europe are well known. What is not so well known is that during 1937–38 he commanded the army garrison in Portsmouth, as is recorded on his statue that is across the road from the D-Day Museum.

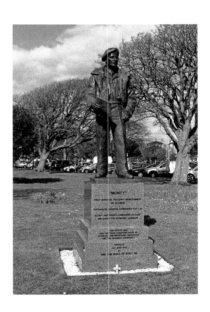

The statue of Montgomery.

# 4. Buildings and Structures

## A Recent Cathedral

Though known today as Portsmouth Cathedral, for most of its existence this building was just a parish church. It was consecrated as a chapel in 1196 and dedicated to St Thomas Becket, the Archbishop of Canterbury who had been murdered apparently on the orders of Henry II twenty-six years earlier. It served the new settlement that had been founded by Jean de Gisors in 1180 and was elevated to the status of a parish church in 1250. During the Parliamentarian siege of 1642, the central section was badly damaged and was rebuilt later that century in the classical style popular at the time. Among the many features worth seeing inside are the tomb of the Duke of Buckingham who was murdered literally just up the road, and a thirteenth-century wall painting of the Last Judgement.

## Recycling a Castle

Warblington Street runs parallel to and north of Old Portsmouth's High Street. Its name had been Hogmarket Street but it was renamed after houses in it were built of stone taken from Warblington Castle, which was destroyed during the Civil War of the 1640s. None of the stone buildings in Warblington Street survive today, but you can still see part of Warblington Castle at the village of that name, which lies down a lane near Emsworth by the north-west part of Chichester Harbour. The castle was actually a Tudor house surrounded by a moat and, if you go to the area around Warblington's parish church, you can see the castle's gateway tower beyond a farmyard.

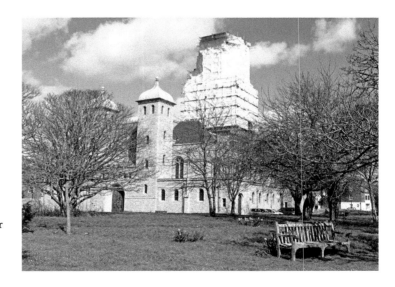

Portsmouth Cathedral. The scaffolding was for the replacement of the Golden Barque on the tower.

Warblington Castle.

## Two Distinctive Buildings

Next to the Round Tower there is an unusual and distinctive building called Tower House – a name that is doubly suitable since it also has a tower of sorts of its own. It was the home of William Lionel Wyllie (1851–1931) who is remembered as a talented artist who worked on maritime themes and also illustrated his own books. Wyllie also produced the 42-foot-long panorama of the Battle of Trafalgar that is displayed in the National Museum of the Royal Navy in Portsmouth Historic Dockyard. If you go past Tower House, it is worth looking for an arch on the side of the building facing Tower Street. This is inscribed with the exact latitude and longitude at which the building is located.

Groundlings Theatre in Kent Street, Portsea, is a rare survivor of Second World War bombing and later redevelopment in this area of the city. It is also an historic and attractive building, which, though now in an open and detached setting, looks as though it should be part of a terrace of similar buildings. The building dates from 1794 and its nickname 'Old Benny' reflects its original use. The ground floor contained Portsmouth's first free school and the first floor was the Old Beneficial Hall, in which theatre performances and various meetings took place.

## Portsmouth's Defences

The fortifications of the town that had been built around the mid-sixteenth century were demolished in the 1870s. They had become obsolete in military terms, especially because of advances in artillery technology, but perhaps more importantly they were an obstacle to the expanding town, since traffic between Old Portsmouth and the new suburbs had to pass through narrow gateways. The civic authorities undoubtedly saw that they occupied a sizeable chunk of land that could be put to other uses, not least housing.

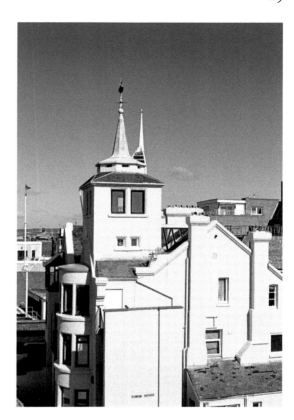

*Right*: Tower House.

*Below*: The arch on Tower House.

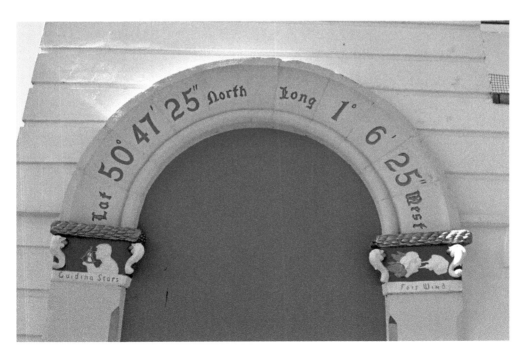

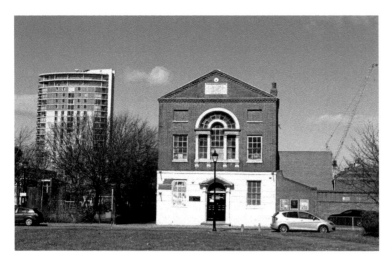

Groundlings Theatre.

One element that survived the demolition was the Landport Gate. There must have been a gateway here since the fortifications were constructed, but the present one dates from 1760 and, like a number of monuments and public buildings in Portsmouth, it was built of Portland stone from Dorset. The gate itself was presumably saved for nostalgic reasons as it had been the main gate through the fortifications, but now it is one of those cases where a monument has lost its context and so is difficult to appreciate properly. Today, it is not even a thoroughfare and stands within a wall next to a busy road, making it difficult to appreciate that it was once within an impressive line of earth ramparts and that you went out of the old town through it to see a sizeable moat beyond.

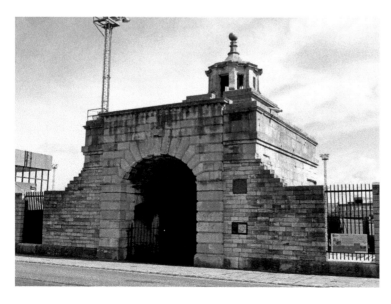

Landport Gate.

## DID YOU KNOW?

The building that now houses Portsmouth City Museum was constructed in 1893 as Clarence Barracks and only became a museum in 1973. Clarence Barracks was part of a larger barrack complex, of which Ravelin House across the road by the park was originally the garrison headquarters. By the corner of the High Street, what is now the main building of Portsmouth Grammar School was built in the 1850s as Cambridge Barracks. The school only moved into the building in 1926.

There is quite a contrast to the slightly forlorn Landport Gate at the south-east corner of the fortifications, where much still survives. You can really get an idea of how impressive the complete circuit must have been and even see a surviving section of the moat that once encircled the town. This was on the side of Old Portsmouth towards Southsea Common; the defences must have been left alone so that people could walk across them on their way to strolls on the common.

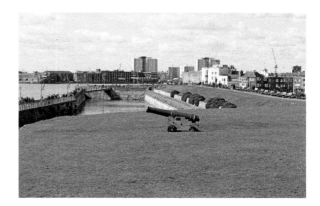

The view from King's Bastion on the well-preserved section of Portsmouth's fortifications.

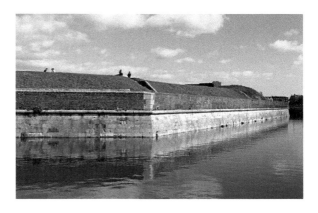

The surviving section of the moat.

## The Royal Garrison Church

Just within these fortifications is the Royal Garrison Church. This was once part of a much larger complex of buildings that was founded around 1212 by Peter de Roches, Bishop of Winchester, as a hospital and almshouse (the two functions tended to overlap). It was known as the Hospital of St Nicholas and St John the Baptist or the *'Domus Dei'*, Latin for 'House of God'. The Master of the establishment was in charge of six monks and six nuns, presumably because it cared for people of both sexes.

After Henry VIII's Dissolution of the Monasteries, the buildings here became the residence of the Governor of Portsmouth. After what became known as the Old Government House was demolished in 1826, the green that was laid out in its place was used to drill troops and, again, for the people of the town to promenade on. Today, a mortar in the corner of the plot around the Royal Garrison Church marks the position of Old Government House. The church was to lose its roof in a 1941 air raid.

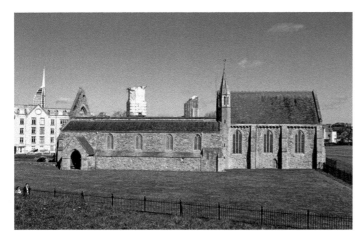

The Royal Garrison Church.

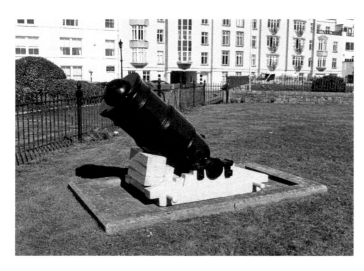

The mortar marking the location of Old Government House.

## Collected Monuments

Along the esplanade on Southsea Common near Clarence Pier, there is a group, or perhaps scatter is a better word, of monuments. Some are more obvious than others, but all of them have a story. Many date from around the 1860s and originally were set more randomly along a longer section of the esplanade back towards Old Portsmouth, then in the 1880s a borough engineer collected them more closely together roughly where they are today.

Heading east from Clarence Pier, the first that we encounter just past the hovercraft terminal, is the best known of the group – the Trafalgar Monument that incorporates the anchor of Nelson's flagship, HMS *Victory*. In 1852, the anchor was set on a granite plinth and placed at the approximate spot where Nelson left Portsmouth and the British mainland for the last time, being moved to this side of Clarence Pier some thirty years later. Inscriptions give details of the battle, such as, 'The British fleet consisted of 27 sail of the line; that of the allies of France and Spain 33, of these 19 were taken or destroyed by Lord Nelson'. In reality, so much of the anchor has been repaired and replaced over the years that only a part of what we see today was actually at the battle.

Just past the Trafalgar Monument, we encounter the Peel or Shannon Naval Brigade Monument. It dates from 1860 and is the first of several here erected by ships' crews on their return to their home port. It was erected in 1860 by the officers and crew of HMS *Shannon* in memory of Captain Sir William Peel and those other officers and men of a unit called Shannon's Naval Brigade who died in the Indian Mutiny of 1857–58. Captain Peel was the third son of the former Prime Minister Sir Robert Peel and formed the unit specifically to fight on land during the mutiny. It was involved in a siege at Lucknow in North East India and the bronze decoration at the top of the monument was made from part of a cannon captured during that action.

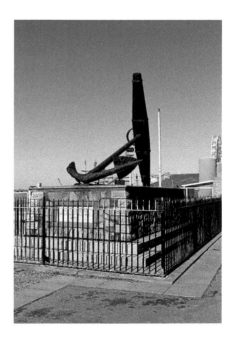

The Trafalgar Memorial.

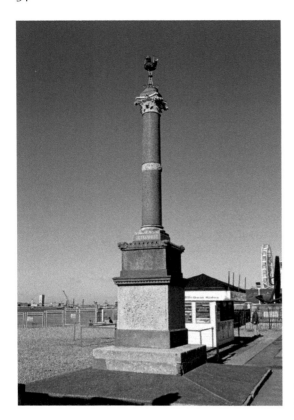

The Peel or Shannon Naval Brigade Memorial.

Past the kiosk and the shelter, there is a monument with what, at first, looks like a mass of spikes sticking out of the top. Get closer and you see that this is a variety of 'spoils of war' – there are a cannon, an anchor and numerous other items. The whole thing is the Chesapeake Monument, set up by the returning crew of HMS *Chesapeake* to record a four year commission (1857–61) on which it was sent, and to commemorate comrades who did not survive. Long inscriptions on each of the four sides have now all but worn away, but fortunately a record has been kept. The commission, which the monument rightly terms 'eventful', involved action in the capture of the Taku forts in China, followed by fighting in the Indian Mutiny like the crew of HMS *Shannon*. This was followed by then a diversion to Arabia before a return to the campaign in China (a bell taken during the Taku forts campaign by HMS *Orlando* is still on display in Victoria Park).

Past the headquarters of Southsea Rowing Club and the beachside restaurant there is the Trident Memorial. This is a four-sided obelisk of pink granite set on a stepped base, with an inscription that reads, 'To the memory of forty-four Officers and Men of H.M.S. Trident who died of yellow fever in the short space of six weeks during the unusual epidemic at Sierra Leone 1859. Erected by Commander F.A. Close and the surviving Officers and Men.' On the back there is a further inscription which states, 'Re-erected by Admiral Close, 1877.' So, presumably, Close was promoted in the intervening couple of decades.

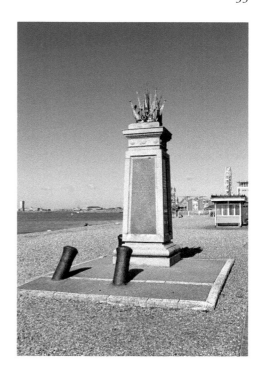

The Chesapeake Memorial.

The Trident Memorial.

The next is the only one of the group across the road on the grass, and indeed it is one of Southsea Common's iconic features – Portsmouth Naval Memorial. From a distance across the Common you probably only see the column, but there is a large area at the base that is worth closer examination. Its background is the loss of 45,000 Royal Navy personnel during the First World War and a wish to commemorate all of these men and women, many of whom had no grave having died in battle at sea.

After the war, the authorities decided that the best way to commemorate these people was the erection of three identical memorials at the main bases from which many of them sailed (the other two were Plymouth in Devon and Chatham in Kent). The memorials were designed by Sir Robert Lorimer and incorporated sculpture work by Henry Poole. Portsmouth's example was unveiled on 15 October 1924 by the Duke of York who, twelve years later, became George VI and was the present queen's father. As part of the same programme, memorials of different design were erected in other parts of what was at the time the British Empire (Canada, New Zealand, Hong Kong and the Indian subcontinent). The main element of the original is the column with four lions near the base, and an upper section of ships' prows and winged figures holding a globe.

The low enclosure that extends out onto the common was added in 1955 to remember the dead of the Second World War. It was designed by Sir Edward Maufe. As with the earlier part of the monument, there are plaques bearing lists of the names of those who are commemorated, as well as guarding figures of a soldier and a sailor. The monument also has a number of very informative and well-designed interpretation boards.

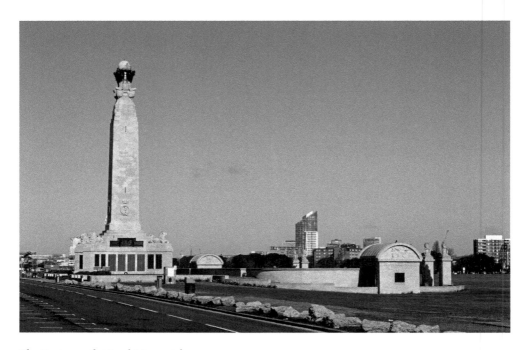

The Portsmouth Naval Memorial.

The Aboukir Memorial is across the road from the Naval Memorial. This four-sided obelisk on a stepped base is on the sea wall and must have been reset here during coastal defence works. Inscriptions explain that it was erected by Commodore De Horsey and the officers and men of HMS *Aboukir* in memory of forty-eight of their comrades from the ship who, again, died during a yellow fever epidemic (this one at Jamaica in 1873–74). HMS *Aboukir* was launched in 1848 and named after a military action in Egypt in 1799 – the war against Napoleon in which a British fleet took part.

Further along the esplanade is the last of the group – the Crimean Monument. Though smaller than the Naval Memorial, it is impressive enough. It commemorates the Crimean War, which took place between 1853 and 1856 between Britain, France, and the Ottoman Empire of Turkey on one side, and Russia on the other. Much of the fighting took place in the Crimean Peninsula, including its most famous incident, the Charge of the Light Brigade. The monument is inscribed with the names of six military actions from that war: Inkermann, Balaklava (where the Light Brigade's charge took place), Alma, Sebastopol, Kertch and Sveaborg. The last of these is in present-day Finland, illustrating how the war was much more widespread that its name suggests. Two longer inscriptions read, 'Erected in memory of those brave soldiers and sailors who during the late war with Russia died of their wounds and are buried in this garrison' and 'Erected by the Debating Society of Portsmouth aided by their fellow townsmen, June 10th 1857.'

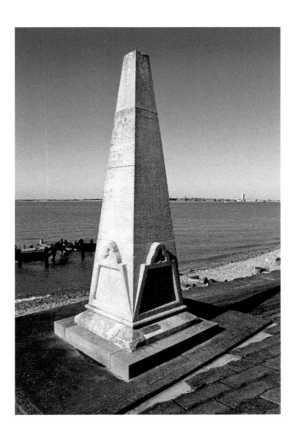

The Aboukir Memorial.

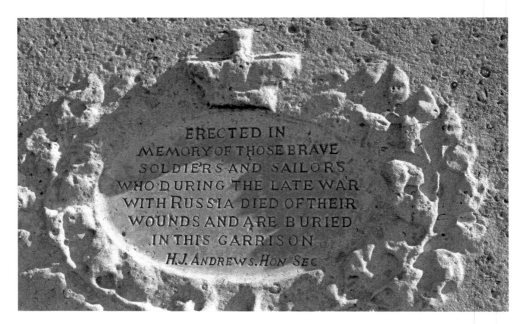

ERECTED IN
MEMORY OF THOSE BRAVE
SOLDIERS AND SAILORS
WHO DURING THE LATE WAR
WITH RUSSIA DIED OF THEIR
WOUNDS AND ARE BURIED
IN THIS GARRISON
H.J. ANDREWS. HON SEC

One of the inscriptions on the Crimean Monument.

However, there is another monument to mention in this group. Apparently there was another obelisk that originally marked the boundary of the Borough of Portsmouth but that has not been seen since the 1930s – maybe it was moved during the Second World War when coastal defences were set up here. It is claimed that the remains of John Felton (about whom there will be more later) were displayed on it in 1628, but a surviving photograph indicates it dated from the eighteenth century.

## Features of Hilsea

Another obelisk, this one marking the borough boundary, survives in Hilsea. It is near the junction of London Road and Torrington Road (on the right as you are heading out of the city), and is set back from the pavement a little next to a car dealership. It is a four-sided obelisk on a pedestal and has the borough arms near the top and inscriptions that explain to any passers-by who can read Latin that it marks the boundary of the borough and dates from 1799. A magistrate called Revd George Cuthbert is also named on it, though it is not stated what his exact involvement in the monument's erection was. There is also a bronze plaque, clearly added later, that explains in English that this obelisk marked the boundary of the borough before it was extended in 1832.

There is also an historic milestone further along London Road in Hilsea. This is easy to miss, but look for it on the left-hand side just before the last road junction ahead of the bridge over Ports Creek. It dates from the eighteenth century, is made of Portland stone and it has been partly defaced. The lower part states, 'Petersfield 14 miles', but the upper part of the text is missing. It is an obvious guess that this had given the distance to Old Portsmouth, which is 3 miles.

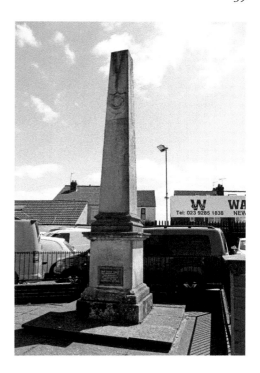

The borough boundary obelisk in London Road, Hilsea.

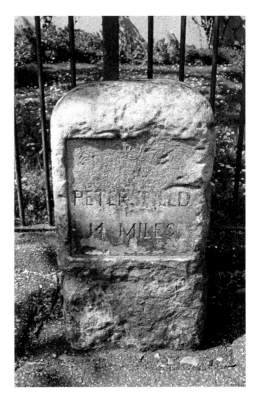

The milestone in Hilsea.

## DID YOU KNOW?

Two landmarks of Old Portsmouth are the Round Tower and the Square Tower. The Round Tower was the first stone fortification in the town, built in 1418 in response to French raiding. The Square Tower was not built until 1494 and was not meant for defence – it was the residence of the Governor of Portsmouth originally. Then from 1545 (the year of the French attack that caused the sinking of the *Mary Rose*) it was used as a store for gunpowder. The thick walls would have protected the contents from enemy artillery and the good citizens of Portsmouth from any accidental explosions.

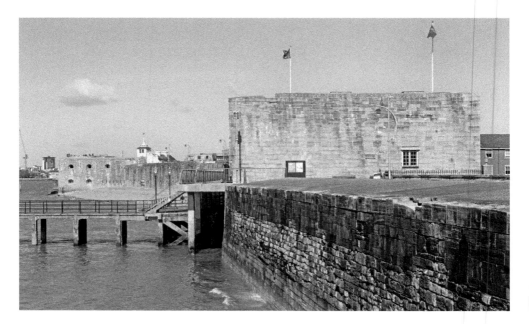

The Square Tower with the Round Tower beyond.

## DID YOU KNOW?

The tower of the Kingston church (or the Church of St Mary as it is known more correctly) is a major landmark of central Portsea Island. The present building dates from the late 1880s and replaced a church that had been built on the site less than fifty years earlier. This building's predecessor dated from the Middle Ages and served the rural communities of the area – it must have been an even more prominent landmark in the open countryside.

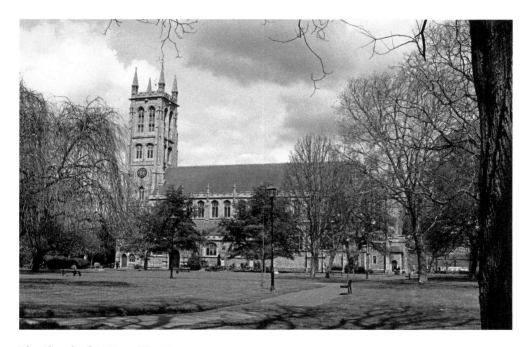

The Church of St Mary, Kingston.

# 5. Expanding Portsmouth

Portsmouth's expansion beyond its old defensive walls has many stories to tell, not least from the houses and other buildings that formed this expansion. Although Second World War bombing and more recent redevelopments have had a major impact, you can still get an idea of when an area was first developed from the styles of the buildings. For instance, there are late Georgian buildings in some of the streets beyond the walls, then swathes of Victorian terraced housing in central Portsea Island and down towards Southsea, and large twentieth-century estates where the city spilled over onto the mainland.

## Portsea Appears

The earliest significant expansion outside the defences was the development of Portsea. Portsmouth Common lay roughly to the north of the town, and a chunk of it had been taken for Henry VII's dockyard. In the early eighteenth century, shipwrights had been trying to build houses for themselves on the common, presumably because they could not afford land prices within the walls, but had met with official opposition. They required the intervention and support of Prince George of Denmark, consort of the ruling Queen Anne, to obtain permission to build. A church was vital for a community at this time and a grant of 25 August 1752 gave land for the building of St George's Church. Fifteen of the twenty-one people to whom the grant was given were shipwrights, hence its name of 'The Shipwrights' Church'. The developing area was then renamed 'Portsea' in 1792 by an Act of Parliament.

The Shipwrights' Church in Portsea.

## Expansion Continues

In the latter part of the eighteenth century, there was also expansion in Landport on the north-east side of Old Portsmouth. Before it was developed, part of the area was called 'Halfway Houses' after a pub here called the Halfway House – maybe because it was halfway from Old Portsmouth to Kingston. The name 'Landport' presumably came from its being outside the Landport Gate. Around 1900 most of Landport was housing for workers in the naval dockyards. Then, after extensive wartime damage, it was decided to make it much more commercial (the former residents were mostly relocated to the new estates to the north) and it is now a true 'city centre'.

The town also began spreading south-east a little later. Although Southsea is first recorded in Tudor times in the name of the castle, there was no settlement here for over 200 years. Rather, 'Southsea' was the name of an area containing Southsea Common and a few scattered farms. It started to develop about 200 years ago especially when, in 1809, the 'minerals streets' were laid out on land belonging to a Thomas Croxton; at first, the growing development was called 'Croxton Town' rather than 'Southsea'.

The 'minerals streets' were so called from their names like copper, nickel, silver and stone, which presumably reflects the industrial employment of the workers for whom they were built, as well as confidence in the benefits of the Industrial Revolution. You can still see these streets today – off the south side of the western end of Kings Road. Very few older buildings are here, presumably the result of bombing, but the names and the street layout survive.

Further north, Somerstown was developed from the 1820s as a new suburb. It was developed on land belonging to a man called Somers, hence the name in the same fashion as Croxton Town.

Commercial Road.

*Above*: Street signs of 'minerals streets'.

*Right*: Street signs of 'minerals streets'.

## Space for the Living and the Dead

As the expansion proceeded, it was not all about squeezing as many houses into the land as possible. There was a clear idea that the people living in these new areas needed space for leisure so, for example, in Milton on the east side of the island, a park was formed around Baffins Pond and Milton Common was left undeveloped. More good evidence of planning for leisure can be seen in the two golf courses that occupy land on which many houses could have been built.

Plenty of room was also set aside for the dead in the expansion of Portsmouth. Before the nineteenth century, most people were buried in the churchyard of their parish church. These were often relatively small, so that whenever a new grave was dug, earlier burials had to be disturbed. Previously, this was generally accepted as inevitable, but in the nineteenth century it was commonly held that a body had to be intact for the body to be resurrected at the Last Judgement. This, along with the increasing populations, were factors behind a rise in new and much larger cemeteries on the edge of towns and cities where relatives could bury their dead without fear of future damage to the bodies. Portsmouth was no exception, with Mile End Cemetery opening on 23 November 1831, followed later by Highland Road Cemetery in Southsea and the larger ones at Kingston and Milton. Mile End Cemetery was covered over when the M275 was constructed in the 1960s.

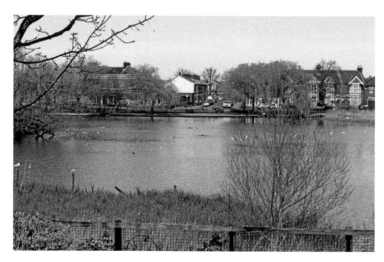

Baffins Pond.

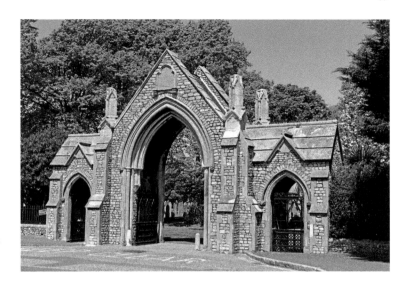

The ornamental gateway of Kingston Cemetery, which opened in the 1850s.

## Kingston Prison

The necessary matter of dealing with crime was also taken into account in the expansion. Kingston Prison was built to the east of Kingston Cemetery and opened on 31 August 1878. It looks like a fortress, though for keeping people in rather than out. A description from around 1900 says that 'the prisoners are mostly employed on the treadmill, grinding corn, and at nosebag, coal sack and hammock making, both for Her Majesty's service and the public.' This was in the days when the prisoners had to earn their own keep, and there were also elements of teaching them the value of honest labour, probably tiring them out so they caused less trouble.

## Portsmouth Airport

Many younger people will not realise that Portsmouth once had its own airport. This was on the north-east corner of Portsea Island, which is surprising considering how crowded the island can seem. It was built by the local corporation between 1930 and 1932 and construction was helped by the naturally flat landscape, although drainage work was also necessary. The proximity of Langstone Harbour was seen as an advantage at the time since this could provide a sheltered location for seaplanes, which were seen as having a bright future. Indeed, Portsmouth's South Coast location was seen as an ideal starting point for seaplane services to the then widespread British Commonwealth.

Early services that operated from the airport included ones to the Channel Islands, which remained one of the main destinations throughout the airport's history. The end finally came in the 1970s after a period of decline: the runways here were relatively short grass strips while airliners increasingly required longer ones with tarmac surfaces. While resurfacing was perhaps possible, there was no easy way to extend the runways without massive reclamation works. Two accidents in the late 1960s did not help the case either – both occurred when landing aircraft were unable to brake sufficiently when the runway grass was wet.

Industrial areas had grown up around the airport and, after the closure, the site of the airport itself was redeveloped with houses and more business parks. The memory of what was once here survives in the names of Airport Industrial Estate and Airport Service Road.

## Onto the Mainland

Portsmouth's expansion onto the mainland started earlier than you might think: housing estates were built in Cosham during the 1920s and 1930s. However, it was after the Second World War that expansion onto the mainland really took off, as the city struggled to find housing for people who had lost their homes to bombing. The best known of the estates dating from this time is Paulsgrove. Previously, this area had been farmland belonging to the Cooper family, who lived in Paulsgrove House. The house was on the A27, near the present entrance to Port Solent, and was demolished in 1970 as it lay in the path of the M275, which runs into the city off the M27. Photographs indicate it was an elegant country house that once must have had fine views across Portsmouth Harbour to Portchester Castle.

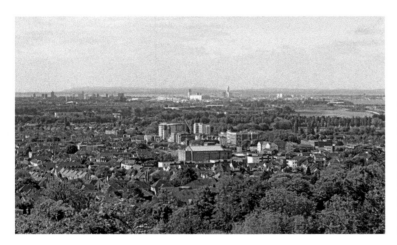

A view from Portsdown Hill towards the city centre, showing Portsmouth's expansion across Portsea Island and beyond. There are still plenty of trees and open spaces.

## DID YOU KNOW?

The farms and settlements of Portsea Island had been interacting with Portsmouth long before they were swallowed up. The farms found a ready market for their produce in the expanding town, and some villages became the homes of people from the town. A good example is Fratton, which was originally called 'Frodington'. In 1801, it is recorded that several successful traders had elegant homes here (they presumably commuted to work in the town) and other occupants were retired seafarers.

## Historic Survivals

Though Portsmouth has swallowed up a number of settlements on Portsea Island and more recently on the mainland, not every trace of the old farms and villages has been lost. The old tracks around a village sometimes survive in the modern road network and there are a number of historic 'pre-Portsmouth' buildings to be seen here and there.

There are two good examples in Hilsea. Gatcombe House is set back on the left side of Copnor Road as you head towards Hilsea. This eighteenth-century country house can be seen behind a more modern extension when viewed from the pavement.

Further on, the road bends and here is a Toby Carvery. It was once Green Farm – the attractive farmhouse that may date from the fifteenth century is now the main bar. The adjacent converted barn is around 200 years old. Green Farm was the last working farm on Portsea Island, being converted into the Carvery in the 1990s.

Over on the mainland, Wymering Manor lies a short distance up the lane at the side of the parish church. The main building dates from the seventeenth century, but it incorporates parts of a medieval building. Wymering parish church itself also dates from the Middle Ages, although most of what you see today is the result of a major restoration in the 1860s.

Gatcombe House.

The Toby Carvery that was formerly Green Farm.

Wymering Manor.

# 6. Literary Connections

## Jane Austen and Family

The novelist Jane Austen (1775–1817) spent the last eight years of her life at Chawton in north-east Hampshire. She also had links to the Portsmouth area through her brothers, Charles and Francis, who both served in the navy.

Francis, who was born in 1774, eventually rose to the rank of admiral, living out his days at his home of Portsdown Lodge in Widley, on the north side of Portsdown Hill. He died in 1865, having survived his novelist sister by forty-eight years, and was buried in the churchyard at Wymering, then a small village.

Francis was married twice: firstly to Mary Gibson, who died in 1823 and with whom he had several children, then to Martha Lloyd, a great friend, confidante and fellow recipe-collector of his sister Jane. Martha was ten years older than Francis and, when she died in 1843, she was also buried at Wymering. A Cassandra Austen who was buried at the same church in 1849 must have been a child of Francis' first marriage.

Another Cassandra (1773–1845), who was Francis and Jane's elder sister and a noted watercolourist, died while visiting Francis but her body was taken to the family home of Chawton for burial.

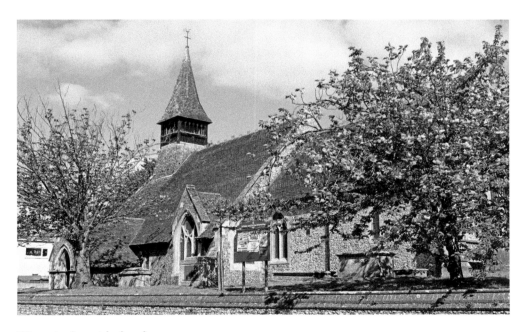

Wymering's parish church.

## Mansfield Park

Jane Austen's strongest association with Portsmouth, though, is through her novel *Mansfield Park*, which is partly set in the town during the early years of the nineteenth century. It provides quite a few insights into what contemporary life was like here. The novel's heroine is called Fanny Price and her mother is one of three sisters. The others made good marriages (i.e. they married rich men) while Fanny's mother married a navy man whose career was not particularly successful and who had retired at the start of the novel when Fanny is around ten years old. Interestingly, the family are clearly living in Portsmouth and presumably have done since before Fanny was born, yet the town is not mentioned specifically in this early part of the story – perhaps a contemporary reader would assume that was where they lived since they were a naval family.

Fanny's parents are struggling to bring up a large number of children and her aunts decide to help their sister by 'adopting' one of them – this turns out to be Fanny. So, off goes our heroine to live with an aunt whose very stately home is Mansfield Park in Northamptonshire. Much of the central part of the novel is about Fanny adapting to life here, among relatives who rather look down on her and her ways. Early on, she does not help her cause by talking of the Isle of Wight as 'the Island' (still a Portsmouth way of referring to it), which is taken to mean that she thinks it is the only island in the world.

Later, and while Fanny is still living at Mansfield Park, her brother William comes to visit. William is on leave from the navy, where his career is doing well (his character is modelled on Austen's brother Charles). One evening, he comments that if he were back in Portsmouth that evening he would have gone to the assembly night dance, where the 'Portsmouth girls turn up their noses at anybody who has not a commission' – that is, they are only interested in naval officers, not the lower ranks.

Further on, Fanny is sent back to Portsmouth for a stay with her parents. She is accompanied by William, who has been promoted to lieutenant through family influence (about which no one sees anything wrong). On returning to the town for the first time in about ten years, they enter via the drawbridge of Landport Gate, as would have been normal, but before this Fanny looks around to 'wonder at the new buildings'. She is seeing the expansion of Portsmouth beyond its walls that was then in its infancy.

As the novel nears its conclusion (which I won't give away), we learn that, after attending service at the Royal Garrison Church, Fanny's mother 'took her weekly walk on the ramparts every fine Sunday throughout the year'. As we have seen before, such promenading was typical for a Portsmouth resident of the time.

## Charles Dickens and Nicholas Nickleby

The house where the novelist Charles Dickens was born is a well-known tourist attraction. His parents, John and Elizabeth, were married in 1809 and rented this house, No. 1 Mile End Terrace, for £35 per year. This was an exorbitant sum by the standards of the time, but this was during the Napoleonic Wars and many people were desperate for housing locally – John himself worked in the Naval Pay Office at the Dockyard. Charles was born on 7 February 1812 and the family moved to Southsea in June of the same year, so he would have had no memories of the house.

Dickens' birthplace in Mile End Terrace.

The location of the house is of interest. Mile End Terrace is in Old Commercial Road on the north side of Landport. 'Mile End' must refer to the area being around a mile from Old Portsmouth. Old Commercial Road is so named because it was a continuation of the Commercial Road that is the modern shopping centre, and was part of the main road north out of Portsmouth. This section is now bypassed by a section of dual carriageway that is, in turn, called Mile End Road.

Today, Old Commercial Road is blocked off by a modern housing development at one end and by a wall with an entranceway for pedestrians at the other. The Dickens connection must have helped to preserve this little area, which is worth visiting even if you don't go to the birthplace. There are historic houses along one side of the road, including that once occupied by the Dickens family's landlord – a section of tramlines even survives in the road itself.

Part of one of Dickens' great novels, *Nicholas Nickleby*, is set partly in Portsmouth. His family are in a poor financial condition so Nicholas, perhaps rather hastily, leaves (if not abandons) his mother and sister behind in London and sets off to find his fortune. He and his companion Smike (who Nicholas has rescued from the brutally-run school of the inept Wackford Squeers in Yorkshire), set off to walk to Portsmouth, intending to find employment on a ship, but at an inn meets members of a theatrical family heading the same way and are persuaded to join their company instead.

The ease with which Nicholas fits in as a scriptwriter once they reach Portsmouth and knocks off successful plays reads like Dickens' satire on the low standards of the

Old Commercial Road and its tramlines.

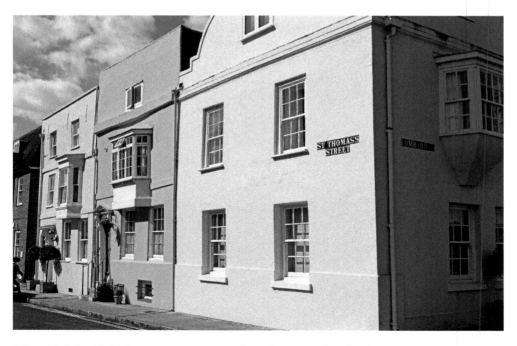

When Nicholas Nickleby comes to Portsmouth, Dickens says that the theatre company's manager, Mr Crummles, lives in St Thomas' Street – maybe in one of these!

contemporary theatre (i.e. anybody can do it), and this is reinforced by the description of one particular play that Nicholas sees the company put on.

We know of Dickens as a great commentator on social issues and for his insightful characterisation, but his ability to be just plain funny is less recognised. His account of the play is full of phrases such as the following: 'This outlaw's wife was somehow or other mixed up with a patriarch, living in a castle a long way off, and this patriarch was the father of several of the characters, but he didn't know exactly which...' You read this and know that Dickens must have seen plays of this sort, where you do your level best to follow the action but don't really know what is going on, then come away with the feeling that neither did the actors and possibly the writer.

Although the theatre at which this action takes place is not named specifically, it is generally assumed to be Portsmouth's original Theatre Royal, which was built in 1761. It was one of several buildings demolished in the 1850s when Cambridge Barracks was built.

## A Visitor from Russia

At the tip of Spice Island there is viewing area with stunning views of Portsmouth Harbour, as well as of the Spinnaker Tower, Gunwharf Quays and the Naval Dockyard. A plaque on the low wall here can be missed easily, but it is worth a look. It records in both English and Russian a visit made to Portsmouth in 1852 by Ivan Alexandrovich

The viewing area at Portsmouth Point. The Goncharov plaque is out of shot to the right.

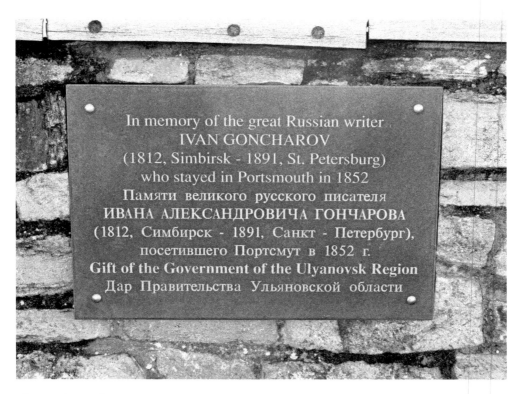

The Goncharov plaque.

Goncharov (1812–91) on a Russian frigate. Goncharov has become a famous writer in his homeland, and his novel *Oblomov,* which told of a character who spent his time dreaming of what he was going to do rather than actually doing it, was a favourite of the Communist governments there as an object lesson. The plaque was set up in 2012 in association with the Russian government to commemorate Goncharov's '200th birthday'.

## A Visitor from Dorset

The novels of Thomas Hardy (1840–1928) are mainly set in a fictionalised version of the part of south Dorset where he was brought up. However, he sometimes ventured further afield, and his short story 'An Imaginative Woman', which forms part of his *Life's Little Ironies* collection, is set partly in Southsea (although, in his usual style, Hardy changed the name to 'Solentsea'). The story revolves around Ella Marchmill, the wife of a Midlands industrialist, and the affair she has with a poet when her family are on holiday at 'Solentsea'. They stay in a hotel that is part of a terrace called New Parade. Hardy generally based locations in his novels on real places whenever he could, and while there is no 'New Parade' in Southsea, I think his description of this terrace as 'facing the sea' fits best the one at the eastern end of South Parade just before South Parade Pier, as other Southsea terraces generally have the common or Canoe Lake in front of them.

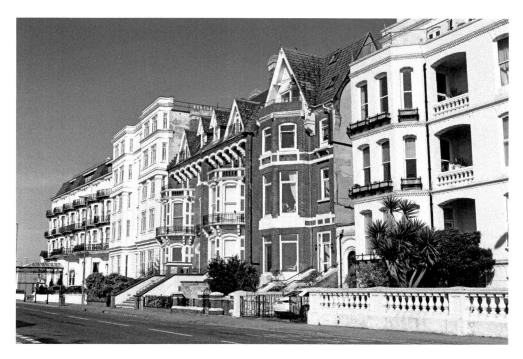

The terrace in Southsea that Hardy may have had in mind.

## The Creator of Sherlock Holmes

Arguably Portsmouth's best-known literary connection is with Sir Arthur Conan Doyle (1859–1930), the creator of Sherlock Holmes. Conan Doyle was born in Edinburgh and studied medicine in the city's university, then, in 1882, he came to Southsea to set up his own medical practice. This was not a great success at first, affording the good doctor plenty of time to pursue other interests, including writing.

He tried writing short stories for magazines first of all, some of which were published. He was also interested in the application of scientific techniques to crime detection, something of a novelty in those days, and wrote a novel about an eccentric genius working in this field – Sherlock Holmes – who is seen through the eyes of his associate, Dr Watson. Conan Doyle's original intention was a single story about Holmes, but the great public interest in his creation led to a second novel. Further Holmes tales, mostly short stories, followed for years afterwards, but Conan Doyle wrote these in London, having moved there in 1890.

Like many novelists, Conan Doyle modelled characters on people he knew. Sherlock Holmes came from Dr Bell, one of his old lecturers at Edinburgh University. In Grove Road, Southsea, just around the corner from Conan Doyle's own practice, was where Dr James Watson had his surgery.

The fictional Dr Watson (John rather than James) is also given links with the area – in the first Sherlock Holmes novel, *A Study in Scarlet*, we are told that Watson had trained as a military doctor at 'Netley', undoubtedly meaning the Royal Victoria Hospital there.

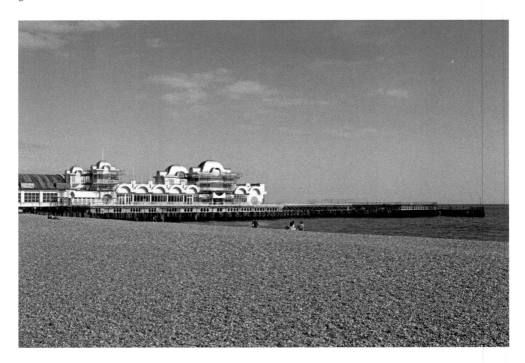

The shingle beach for which Dr Watson pined, with South Parade Pier in the background.

Netley lies around 10 miles west of Portsmouth and the hospital was largely demolished in 1966 – its site is now in the Royal Victoria Country Park. He then served in India and, when wounded, he was invalided out of the Army, returning to England through Portsmouth, like most military personnel of the time. Twice in later Sherlock Holmes novels, Watson yearns for the 'shingle of Southsea', perhaps reflecting the real feelings of Conan Doyle, who was now living in London.

The second Sherlock Holmes novel written in Portsmouth is called *The Sign of Four*. Much of it is set during the Indian Mutiny of 1857 and, though Conan Doyle had never been to India, he got much of his detail from friends in Southsea who were retired military officers and had served there.

## A Modern Writer

We must not forget that literature is still alive and well in Portsmouth. A good example is the Joe Faraday series of police procedural novels, written by local author Graham Hurley, that feature the honest and generally hardworking Detective Inspector Joe Faraday and his colleague Detective Constable Paul Winter, of whom the term 'roguish' is perhaps too polite a description. There were twelve novels in the series, one set in every year from 1999 to 2010. A character who came to the fore in the later novels, Jimmy Suttle, has since become the focus of a continuation series. Though Jimmy has moved to Devon in these novels, the Portsmouth connection continues through his estranged wife Lizzie, who has returned to Portsmouth and her old job on the news.

## DID YOU KNOW?

Since Sherlock Holmes is such a master of the scientific approach to detective work, it is surprising to many people today that Conan Doyle had a strong interest in spiritualism. However, there was less of a contrast in Conan Doyle's time when a number of people tried to investigate claims of paranormal activity scientifically. Conan Doyle's interest in the subject increased later in his life, but was already present when he lived in Southsea; he attended séances at the Phoenix Lodge in Portsmouth High Street.

The site of the Phoenix Lodge at No. 110 High Street.

# 7. Famous People

## A Short But Momentous Visit

The former George Hotel in the High Street of Old Portsmouth is generally stated as the place where Horatio Nelson spent his last night in England before heading off on the campaign that resulted in his great victory at the Battle of Trafalgar, but also his own death. It appears, though, that he only reached Portsmouth around 6.00 a.m. on Saturday 14 September 1805 and had time for breakfast and a couple of meetings but little else. Nevertheless, Nelson had stayed here several times before; it was a favourite location among visiting senior naval officers at the time. He left the hotel around noon and walked through the town to be cheered by crowds of well-wishers before getting into a boat that took him out to his flagship, HMS *Victory*.

The hotel itself was destroyed with much more of the city in the German air raid on the night of 10–11 January 1941; firebombs from this raid also destroyed the roof of the Royal Garrison Church.

There is a statue of Admiral Nelson in Grand Parade, between the Square Tower and the Royal Garrison Church, and close to where Nelson left English soil for the final time after walking from the George Hotel to join his fleet. On the front of the granite base

Commemorative details on the site of the George Hotel.

is the date of the Battle of Trafalgar, 21 October 1805, and, on the side, there is a detailed inscription concerning Nelson that mentions his final stay in Portsmouth. There is also an additional inscription on the three steps below, which is easily missed. This states:

> Here served Horatio Nelson
> You who tread his footsteps
> Remember his glory.

The statue was erected in 1951 in Pembroke Gardens and moved the short distance to its present site in 2005. It is the work of the renowned sculptor Frederick Brook Hitch (1897–1957).

## A Man who Cared

John Pounds (1766–1839) was a local shoemender who undertook various charitable works from his workshop, including teaching illiterate children who would otherwise miss any education. Following his death, the story of his work inspired one Dr Thomas Guthrie of Edinburgh to set up a national system for educating poor children in what were called the 'Ragged Schools' – rather a patronising term by modern standards. The church of the Portsmouth Unitarians in the High Street bears John Pounds' name and his grave is in the adjacent garden, while the John Pounds Centre in Queen Street, Portsea also commemorates his work.

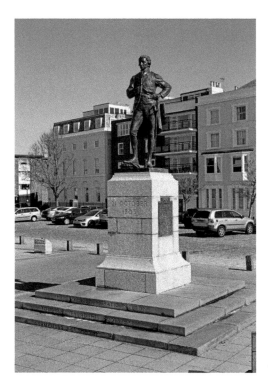

The statue of Nelson.

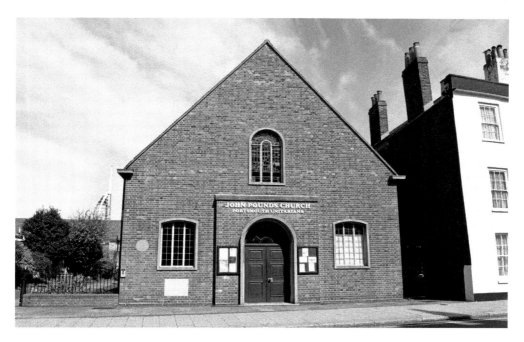

John Pounds Church with the memorial garden to the left.

## The Great Engineer

On the green on the west side of the Shipwrights Church in Portsea, towards the back of Gunwharf Quays, there is a monument to Isambard Kingdom Brunel, who was born on 9 April 1806 in nearby Britain Street (which runs south-east from the square in which the church stands). He went away to school in Hove when eight years old, then on to educational establishments in France where his father Marc was born.

When we think of great engineers of the Industrial Revolution, Brunel is generally the first that comes to mind. As Jeremy Clarkson said in a television documentary about the man, great British engineering projects faded greatly after his death in 1859 'because Brunel had built them all'. His list of achievements includes much of the Great Western Railway, bridges such as the Clifton Suspension Bridge in Bristol and ones that cross the River Tamar near Plymouth, and steamships such as the *Great Western* and *Great Britain* (the latter can still be seen in Bristol).

His father deserves further description too. Marc Isambard Brunel (1769–1849) had experience of carpentry and had served in the French Navy. He fled the country during the French Revolution, which began in 1789. He and his wife Sophie came to England and offered his machinery that automated the production of pulley blocks to the Royal Navy. Before this, the navy's pulley blocks were made by hand, a great deal of work considering that it needed over 100,000 of them every year. The offer was accepted and the building that was used for the purpose, Portsmouth Block Mills, still exists. Brunel's machinery is credited as one of the seminal systems of mass production of the Industrial Revolution. In later life, the elder Brunel, assisted by the younger, constructed the first tunnel under the River Thames.

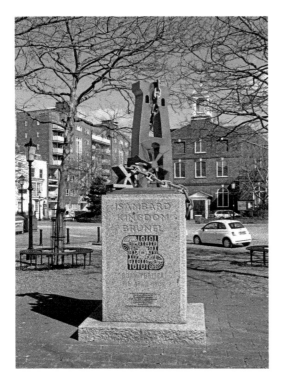

Monument to Isambard Kingdom Brunel.

## A Media Pioneer and a Prime Minister

Alfred West (1857–1937) was an award-winning marine photographer and, from 1897, a pioneer cinematographer who invented the instantaneous shutter and stabilising techniques for using a film camera at sea. He first worked in the family photographic business of G. West & Son in Gosport, then crossed Portsmouth Harbour to work at Nos 72 and 84 Palmerston Road, Southsea, while living round the corner at Rozel (No. 7 Villiers Road). West was acclaimed for his documentary series *Our Navy*, which tested his skill and new technologies for filming at sea, and he was invited to show his films to Queen Victoria and other members of the royal family. He later branched out into other subjects, including filming racing yachts in action, which was particularly challenging for the equipment of the time.

The future Prime Minister, James Callaghan, was born on 27 March 1912 at No. 38 Funtington Road, Copnor. The house is in one of the many terraced streets of central Portsea Island. James was the son of a Chief Petty Officer in the navy, also called James. He attended what was then the Portsmouth Northern Secondary School in North End (now Mayfield School) before leaving the city to join the Civil Service. Callaghan joined the Labour Party in 1931 while living in Kent and, in 1945, became the MP for Cardiff South. He rose to become Prime Minister in 1976, taking over from Harold Wilson mid-term, then losing the 1979 General Election to the Conservatives led by Margaret Thatcher. He died in 2005 and is commemorated locally in James Callaghan Drive, the westward continuation of Portsdown Hill Road.

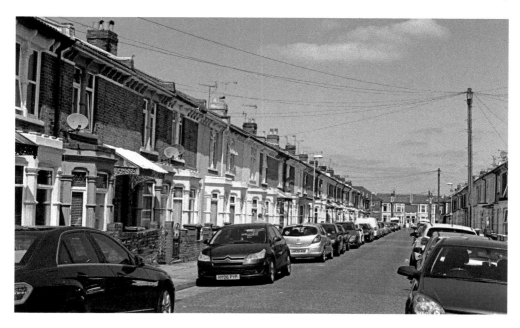

Funtington Road, Copnor. James Callaghan was born in one of Portsmouth's typical Victorian terraced streets.

## The Airpot Attracts a Novelist

Among those attracted to Portsmouth's new airport was Nevil Shute Norway (1899–1960), who went on to become one of Britain's best-known writers of adventure stories during the mid-twentieth century; he wrote under the shorter pen name of Nevil Shute. Previously, he had worked on airship design, but the government support on which his company depended waned following the crash of the R101 airship in France in 1930, which caused the deaths of forty-eight of the fifty-four people onboard. Although Shute's company had not been involved in the R101, airships were now seen as potentially dangerous.

Shute adapted by setting up his own aircraft construction company, Airspeed UK, with a colleague in York. They soon became attracted to the new aerodrome at Portsmouth, where there were facilities close to the runway suitable for their business, making testing of new aeroplanes easier, and where there was also a ready source of workers, many of whom came from the North and the Midlands. And so they moved down in March 1933.

### DID YOU KNOW?

Nevil Shute's Southsea home was No. 14 Helena Road, next door to the property that had been the home of Edwin Unwin, the winner of the Victoria Cross. Both houses have blue plaques that record their former occupants.

For some ten years before the move, Shute had been writing novels and this other career also took off (please pardon the pun) soon after the move to Portsmouth. A key to this occurred in 1936, when one of his earlier novels, *Lonely Road*, was made into a film. Aeroplanes and pilots were generally key elements of Shute's adventure novels and, in one that he wrote in 1938 called *Ruined City,* he used much of his own experience in setting up Airspeed UK. After some successes with this company at Portsmouth, Shute began losing interest in the aircraft business and he was removed by his own company's board in 1938 (the company was in turn taken over by de Havilland in 1951).

For much of this time, Shute lived with his family in Southsea. They then moved to Langstone, then Hayling Island before migrating to Australia in 1950. He is commemorated today in road names around the site of the old airport. Norway Road is not named after the country but Nevil Shute's last name that he dropped to form his pen name, while Marazan Road is named after Shute's first published novel.

## Peter Sellers

The comedian and actor Peter Sellers (1925–80) was born in a house at the corner of Castle Road and Southsea Terrace just across the road from Southsea Common. A blue plaque on the house, which is now a takeaway, commemorates this. His parents were entertainers and he made a particularly early stage debut, being carried onto the stage by a performer at the King's Theatre in Southsea when he was only two weeks old. Sellers was best known as one of the Goons on radio in the 1950s and for various film roles, generally comedies, such as the *Inspector Clouseau* series.

Street sign commemorating two-thirds of Nevil Shute Norway's name.

And the other third.

Peter Sellers'
birthplace, with
a blue plaque
commemorating this
above the door.

## DID YOU KNOW?

In later life, Alfred West moved into the house where Peter Sellers had been born.

# 8. Crime and Criminals

## An Assassination

George Villiers was the first Duke of Buckingham. Born in 1592, he had risen in favour rapidly at the court of James I from his first visit in 1614 to being made duke in 1623, quite possibly because he became the king's lover. As he grew in importance, George became more involved in political and military matters; his actions in general suggest he had been, in modern parlance, 'over-promoted'.

The duke was staying at a house in Portsmouth High Street on 23 August 1628. As he left that morning, he was stabbed by a man called John Felton who had been a captain in the forces under the duke's command in an unsuccessful campaign in France (England and France were then at war – it is tempting to add 'as usual'). It has been suggested that Felton was suffering from what is now recognised as post-traumatic stress disorder, although Felton himself also expressed grievances about a lack of promotion and back pay that he had not received.

Perhaps because of his own state of mind, or maybe because he knew accurately how unpopular the duke was, Felton did not flee but instead announced to the crowd that gathered that he was the killer. So he was perhaps rather surprised to find himself arrested

The house from which the Duke of Buckingham emerged to meet his assassin.

rather than acclaimed. Nevertheless, there was a great deal of popular sympathy for Felton nationally, though it was no surprise that he was found guilty at his trial in London in November and hung soon afterwards. The authorities then decided to send his body back to Portsmouth to be put on display as a warning to others, but his remains were then treated with great respect by the local people – in a way, Felton did finally get his acclaim.

## Execution of a Traitor

David Tyrie, a Scot with a civil position in the navy office in Portsmouth, was hung for treason here on 14 August 1782. He was seen selling information that was to be passed to the authorities in France, with which Britain was once again at war. His sentence was to be hung, drawn and quartered. As was the norm at the time, his notoriety and impending death made him into something of a celebrity and portraits were made of him in the days leading up to his execution. The sentence was carried out on Southsea Common: apparently he was hung for twenty-three minutes, cut down and decapitated, then quartered. So he was probably already dead when cut down, which had become the normal practice for such executions – this was more 'humane' than in Tudor times, when the victim was often still alive when cut down and disembowelled before his body was cut into quarters. It is also said that Tyrie's body was actually torn apart by the angry crowd (many presumably naval personnel who Tyrie's conduct had endangered) and that the local jailer stole the head and later charged people to see it.

### DID YOU KNOW?

The roundabout near the Continental Ferry Port at the western end of Kingston Crescent was once a simple crossroads. In 1823, a person was buried here. This was not the consecrated ground in which people were normally interred, for, in the eyes of contemporaries, the person had committed a major crime – they had taken their own life. Crossroads had been a standard place for burying criminals for centuries up till now. This was the last such burial of a suicide victim in the Portsmouth area – an Act of Parliament stopped the practice a few years later.

## Two Courts Martial

The military also punished their own wrongdoers, although one famous eighteenth-century case concerns an action that we would probably not consider 'criminal' today, maybe just 'prudent'. On 14 March 1757, Admiral John Byng was executed by a firing squad of marines on HMS *Monarch*, which was anchored off Portsmouth. He had been charged at his court martial with failing to relieve the siege by a French force of a British naval base at Minorca in the Spanish Balearic Isles. He had considered that his own forces were too small for the task, so withdrew to Gibraltar. His prosecution was seen as an attempt, unsuccessful as it turned out, by the Duke of Newcastle, soon to be Prime

Minster, to divert attention from his own mistakes in the matter. Byng was convicted not of cowardice but only of 'failure to do his utmost'. When convicted, public opinion turned in Byng's favour but could not stop his execution. Nevertheless, such a draconian punishment for such an act by a senior commander never happened again. Voltaire's statement, in his novel *Candide*, that the English shoot one of their admirals occasionally 'to encourage the others' was a reference to this.

Another court martial of an admiral took place in the Solent later that century. In 1779, Admiral Augustus Keppel was acquitted of 'dereliction of duty' over his actions in command of the British Fleet during the First Battle of Ushant in July of the previous year. The battle was fought off the French coast against that country's fleet and, from the British point of view, the result was, at best, indecisive and possibly a defeat. This outcome was partly Keppel's own fault, though he blamed a subordinate, Sir Hugh Palliser, who was later also court martialled and acquitted. Perhaps the reaction to Byng's execution had an impact on the verdict (and maybe there was the thought that if you court martialled every commander who made a mistake, no one would ever go for promotion). Certainly the trial did not do Keppel too much harm: he lived another seven years afterwards, being promoted to First Lord of the Admiralty and becoming a viscount. Keppel's flagship at the battle had been the same HMS *Victory* that Nelson later commanded at Trafalgar.

## An Unpleasant Profession

In the early nineteenth century, Portsmouth was one of many places in Britain that suffered from the activities of what were euphemistically called 'resurrectionists', but were, in reality, traders in dead bodies. The medical profession required numbers of these for research and teaching purposes, but the only ones they could obtain legally were the bodies of executed criminals. The shortfall was made up in the illegal activities of the resurrectionists, who dug up bodies as soon as possible after burial then sold them – clearly an activity that was extremely distressing to the families of the bereaved.

On 7 January 1825, two men called John Johnson and Henry Andrews were caught with a large trunk at the Star Inn at Portsea, which they were about to take by coach to London. The trunk was found to contain a body. It emerged that this was the fourth body that Johnson had stolen since the previous month from the burial ground of the Royal

### DID YOU KNOW?

Bodysnatching became so prevalent that in the 1820s 'watchmen' were employed to protect the churchyard at Kingston. There are records of them firing guns at 'resurrectionists', and in one case of mistaken identity a man was killed. The Anatomy Act of 1832 effectively put paid to bodysnatching. It allowed for the dissection of donated bodies and of 'unclaimed' corpses (such as some of the people who died in workhouses), making stealing from graves much less lucrative.

Hospital at Haslar over on the Gosport side of Portsmouth Harbour. His accomplice was one William Seymour, who worked at the burial ground maintaining it in the role of sexton.

At their trial, Andrews was found not guilty for lack of evidence (probably he had been hired just to help with the trunk without knowing the contents), while Johnson was fined £50 and imprisoned for six months and Seymour, who was too poor to be fined, received a twelve-month sentence.

## A Duel

During the earlier part of the nineteenth century, the attitude continued that, though technically illegal, duelling was an acceptable way to settle a dispute. What was probably the last fatal duel in England started from a quarrel in Southsea in 1854. Lieutenant Henry Hawkey of the Royal Marines challenged Captain James Alexander Seton of the 11th Hussars after Seton repeatedly made advances to Hawkey's wife. Hawkey confronted Seton at a dance in the King's Rooms and challenged him to a duel, kicking him in the behind to provoke agreement.

They appointed seconds, went to Portsmouth High Street to buy pistols and took the ferry to Gosport. On a shingle beach at Browndown Camp, they fought the duel. When the second pair of shots was fired, Hawkey wounded Seton in the stomach. Hawkey and his second, Lieutenant Pym, tried to stop the bleeding then fled the scene.

Seton was taken back across the harbour to the Quebec Hotel but died a week later, still claiming his innocence. Pym gave himself up and was tried for murder (his mere presence was sufficient for this, by law) but was found not guilty. This gave Hawkey reason to surrender himself and he too was found not guilty after pleading that Seton's death was not due to the gunshot itself but the complications that set in afterwards as a result. Apparently, the verdict was cheered by Hawkey's fellow officers, who undoubtedly had seen his conduct as honourable rather than criminal.

# 9. Geographical Features

Looking at a map of Portsmouth and the surrounding area, we can see how the city has expanded and had a major impact on the landscape, but we tend to think that the general shape of the land and the outlines of the coast have been the same for thousands of years. In fact, natural processes have caused many changes in this time, particularly to the coastal areas, and humanity has had an increasing influence too.

## A Changing Seascape

For much of the time that people have lived on Portsea, it has not been an island. Sea levels were much lower when people returned to Britain at the end of the Ice Age, as much water was still frozen in the ice caps. Gradually, the ice melted and sea levels rose, so that, 3–4,000 years ago, Portsea was cut off from the mainland by Ports Creek.

Langstone Harbour is a comparative youngster. Following the Ice Ages, there were only two rivers here, which are now represented by the Langstone and Broom channels. The former is the larger, and at low water runs round from the north end of Hayling Island, while the Broom flows from the harbour's north-west corner from Ports Creek. Then

The view across Langstone Harbour from the sea wall by Farlington Marshes.

Another view, this
time from near the
Hayling Island ferry.

the rising sea only engulfed the harbour just over 2,000 years ago, i.e. not long before the Romans came to Britain.

Today, Ports Creek keeps Portsea as an island, but only just, as the photograph shows. Local people are well aware that Portsea is an island, but it is definitely a 'secret' for the vast majority of the inhabitants of the rest of this country. Portsea Island is the third most-populated island in the British Isles, after Britain itself and Ireland, which is a great pub quiz question away from southern Hampshire. You will probably get answers such as the Isles of Wight, Man and Skye, then as they tire you might hear Canvey Island or some such, but it may well be closing time before anyone suggests 'Portsea'!

Ports Creek.

## Changing Islands

There has been a great deal of change to the coastline and islands around the north-west side of Portsea Island. Whale Island, or Whaley as it was sometimes known, lies just off Portsea to the north of the Continental ferry port. Maps of the eighteenth and early nineteenth centuries show it as long and thin with a noticeable curve at one end and it was described as 'at high water little more than a speck of mud.' Unsurprisingly, no one lived here then. Apparently, the name 'Whale' came about because the island protruding just above the waterline looked like a whale surfacing. Things began to change around 1845 when the island started being used as a dumping ground for material being dug out of nearby dockyards; so much was added that by the end of the nineteenth century it had increased greatly in size to the more rounded, amost egg-shape we see today.

To the north of Whale Island is Horsea Island, which was described in around 1900 as 'a marsh island, with a farmhouse'. What a contrast to today: with the Port Solent development occupying the north of the island, the landscaped profile of the landfill, much of the south, reclamation work and construction of the motorway interchange, making it debatable whether Horsea is really an island anymore.

Then there is Hilsea, today the suburb on the north-west corner of Portsea. Its name originally meant 'Holly Island' or perhaps the 'raised land in the marsh'. So Hilsea was an area of dry land separated from Portsea either by marshland or even by the waters of Portsmouth Harbour.

## Reclamation

There also has been extensive land reclamation on the eastern side of Portsea Island. The site of the Great Salterns Mansion pub and restaurant was once in an inlet of open water called Gatcombe Haven. Then, in 1665, an area of some 300 acres was reclaimed – its new name 'Great Salterns' came from shallow pools, or salterns, here in which seawater was evaporated to make salt. The present building dates from around 1820, but there was a

Great Salterns by the sea wall of Langstone Harbour.

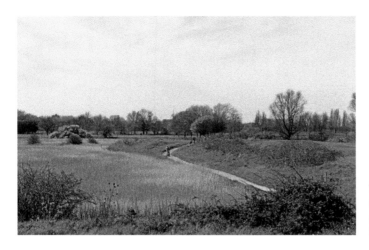

The reclamation works at Southsea Golf Club deliberately left some wet areas.

house here for at least a century before that – it is called 'Lady Carringtons' on a map of 1716. Despite the earlier reclamation, the house was still almost on a separate island until well into the nineteenth century – since then more reclamation has provided the land on which Great Salterns Recreation Ground and Southsea Golf Club now sit.

## The Chalk of Portsdown Hill

Portsdown Hill can look like a barrier between Portsmouth and the rest of the country. It is a ridge of chalk that is an outlier of the South Downs. The highest point is nearly 400 feet above sea level and the whole hill is some 7 miles long, while the ridge top is around 5 miles. The chalk itself formed over 65 million years ago from the shells of innumerable microscopic creatures deposited on an ancient seabed. The name 'Portsdown' means 'Port's Hill' in Old English, the first word undoubtedly a reference to the 'Port' of Portsmouth Harbour. So, in calling it 'Portsdown Hill', we call it a hill twice. Perhaps most importantly, it is a great place to get a view of the whole of Portsmouth, as well as the harbours, Solent and Isle of Wight.

Thanks to human activity, we can see clearly the chalk of which Portsdown Hill is made. The chalk has been quarried for various uses over the years – apparently much was taken around the 1850s when the final phase of Hilsea Lines was under construction. Today we see the results of all this in the quarries on the Portsmouth face of the hill, the largest of which is Paulsgrove Chalk Pit above the head of Portsmouth Harbour. Even from a distance you can still see steps in the exposed chalk that are a result of the quarrying technique used on the steep hillside.

There are lots of stories associated with the quarries. During the Second World War, the Cooper family, who owned Paulsgrove Chalk Pit as well as much other land hereabouts, built two air-raid shelters in that quarry – part of one survives. An underground radio station was dug into a quarry during the same conflict. Further east, by Portsdown Hill Road near the George Inn, there was Jones' Tea Shop from the nineteenth century until 1940. Not only did it have a fine hilltop location, but it used a small 'cave' at the back as a pantry. I suspect this 'cave' was actually an old quarry.

Paulsgrove Chalk Pit on the side of Portsdown Hill, seen from near Portchester Castle.

A closer view of the same quarry taken near Port Solent, showing the 'steps' left by quarrying.

## DID YOU KNOW?

Farlington Marshes on the north-east side of Langstone Harbour were reclaimed in the 1770s by the lord of the manor of Farlington. Several existing small islands were first surrounded by a wood and clay retaining wall, then the area within was drained, presumably through purpose-built channels. It is now an important bird reserve and has several different habitats – grass grazed by cattle, scrub, wetlands and areas of open water.

Farlington Marshes, seen from the sea wall.

An egret looks for lunch at Farlington Marshes.

# 10. Leisure and Sport

## A Bathing House

Quebec House is located by the shoreline not far past the Round Tower into Point. Bathing became fashionable in the eighteenth century and the first bathers in Portsmouth had simply used the beach. This building was then erected in the 1750s as a purpose-built bathing house, paid for by public subscription ('if you help pay for it, you can use it!'). There were four baths inside supplied with fresh seawater through pipes, which must have made bathing safer, more private and often warmer than on the beach. The building was named after the Battle of Quebec of 1759 in the war against France in North America. It later became the 'Quebec Hotel' and was where the duelling victim Seton was brought. It is now a private residence. Other bathing houses were built later along the seafront by Southsea Common.

Quebec House.

## The Battle of Southsea

Leisure could lead to violence in the nineteenth century. In the 1870s, walking along Clarence Pier had become a very popular local pastime, even though there was a fee for doing so. In 1874, the owners of Clarence Pier decided to keep it 'upmarket' by preventing access to those they considered undesirable (seemingly a large proportion of those who wished to use it) then followed this by blocking off part of the adjacent esplanade. The locals reacted by burning the barriers and several nights of riotous behaviour followed, so that, on 7 August, the mayor arranged for the rioters to be dispersed by the police, with armed soldiers standing by if required. The police actions led to injuries but fortunately no deaths. As a result of the protests, though, the barriers on the esplanade were removed.

The events of 7 August became known as the 'Battle of Southsea' and they are depicted on a painting by E. Dugan that now hangs by the stairwell in the City Museum. It was previously on the ceiling of the Barley Mow pub on Castle Road in Southsea.

Two views of the esplanade.

## DID YOU KNOW?

The esplanade is a fine place for a relaxed stroll, but those who built it would not have had pleasant memories afterwards. It was constructed in the nineteenth century by convicts who transported tons of mud and shingle here that was being dug out of the dockyard.

## Two Different Parks

When Portsmouth's defences were flattened in the 1870s, the land that became available was not all used for housing. Around this time, there was a growing realisation that people in the expanding industrial cities were finding it difficult to reach the countryside during their limited leisure hours, and so were missing out on healthy air and exercise. This was not really the case in Portsmouth, where Southsea Common was still readily accessible. Nevertheless, Portsmouth followed the trend for laying out urban parks, using an area of the old defences for the purpose and, in 1878, 'The People's Park' opened. Today it is better known as Victoria Park and, like other new urban parks, it soon became not only somewhere for walking, but also where civic pride was on display, as we can still see from the decorative features and monuments dotted around.

Canoe Lake in Southsea looks like another in the style of Victoria Park, with paths, grass and a café surrounding the lake from which it is named. Indeed it was opened as

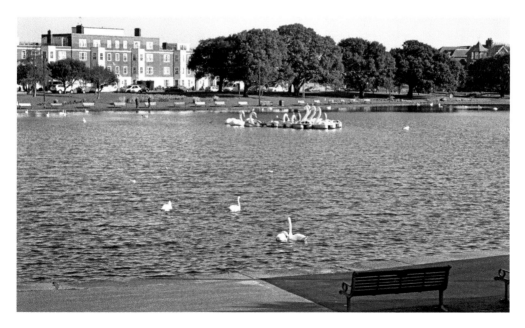

Canoe Lake.

a park on 17 June 1886, just eight years after Victoria Park. However, the lake here is not entirely man-made: previously, the site of the park was marshland and earlier maps show a central body of water of a similar extent to the modern lake. An early eighteenth-century map names this water as 'Great Morrass', which gives a good idea of what it must have been like. It was also called 'Craneswater', the name that has now been transferred to the residential area just to the north, which is the home of Bazza Mackenzie – the main 'baddie' in the Joe Faraday novels. Nowadays you would think that 'Swanswater' would be a better name – not only because of the living ones that spend their time here, but also the swan-shaped boats. There can be up to sixty mute swans, mostly juveniles, here in winter, and they are perfectly adapted to drink from the lake despite it containing saltwater that has percolated through from the sea.

## DID YOU KNOW?

Lidos are open-air swimming pools surrounded by various leisure facilities. Portsmouth's example is Hilsea Lido, which sits between Hilsea Lines and Ports Creek. It dates from the 1930s when lidos were all the rage. Hilsea Lido was designed with a rectangular adult pool, cascades, flower beds and open areas for sunbathing. It is now run as a community endeavour by the Hilsea Lido Pool for the People Trust.

## Southsea not Portsmouth

I would say that visitors to Portsmouth today generally come for the whole package – the sea views, historic sites, excellent shopping, etc. However, this is rather a recent state of affairs: in the nineteenth and well into the twentieth century, visitors were usually on their annual seaside holidays or at least came to the beach for a daytrip. If you asked them where they had come to, they would probably answer 'Southsea', this being seen as the place where you went on holiday, as opposed to the more industrial port of Portsmouth.

## Changes in Sport

Although various sports had always taken place, organised sport for leisure purposes took off in a big way in this country during the later nineteenth century, particularly in the growing towns and cities where there were lots of potential participants and watchers. Portsmouth was no exception to this. This popularity continued into the mid-twentieth century and resulted in lots of local facilities of a type we see less of today, as television and other media have kept people at home. Improved travel arrangements has meant that those who do attend such sports often go further afield to see the big events rather than attending the small stadium down the road.

In the late nineteenth century, football, cricket and bowls clubs were formed in Portsmouth. Horseracing has long been popular and did not always require the formal

Southsea Rowing Club, including a plaque recording its foundation in 1860.

course we expect today. Locally it took place on Southsea Common and Portsdown Hill, then, in 1891, a private course was opened at Farlington, though this closed during the First World War.

In the early twentieth century, a course in Wymering was used for horse, bicycle and motorbike racing, while greyhound tracks in Copnor and Stamshaw were also used for motorbikes. The latter track survived into the twenty-first century. Cycle racing also took place in Alexandra Park and in Southsea.

Portsmouth's maritime location was also used for sport and leisure. Portsmouth Swimming Club was founded in 1875 and had a clubhouse and diving stages on near Clarence Pier and, five years later, the Royal Portsmouth Corinthian Yacht Club moved in close by. Southsea Rowing Club, which was founded in 1860, still has premises here.

## A Gold Medalist

A good example of a successful local amateur sportsman is Clarence Brickwood Kingsbury (1882–1949). He was born in Portsmouth and spent his whole life here. His mother, Martha, had been married to Thomas Brickwood of Brickwoods Brewery, hence his middle name. Kingsbury joined the Portsmouth North End Cycling Club, which formed in 1900 and is still in existence. In the London Olympics of 1908, he won the gold medal in the 20 kilometres cycling competition and another in the group pursuit as a member of the British team.

## DID YOU KNOW?

While living in Portsmouth, Conan Doyle played in goal for Portsmouth Association Football Club. He played under the pseudonym A. C. Smith, the initials presumably being the genuine 'Arthur Conan'. The club was an amateur precursor of the present club and did not play its first match until 1899, nine years after the author moved to London.

## And Football, of Course

'Play up Pompey, Pompey play up' is the Pompey Chimes and it is thought to be the oldest surviving football chant of them all. The title is an adaptation of the tune to which it is sung, 'Westminster Chimes'. The song originated in the 1890s with Royal Artillery FC, who played at the United Services ground in Burnaby Road and referred to the Guildhall clock, whose striking of the quarter hours was used by referees to time the game. When the Royal Artillery team was disbanded late in that decade, the song, and presumably many fans, was transferred to the new Portsmouth FC.

Portsmouth FC was founded in 1898 and has always played at Fratton Park. The first chairman was John Brickwood of Brickwood Brewery. A blue plaque on No. 12 High Street commemorates the exact location and date, 5 April. At first, the team played in the Southern League, then the most important league in southern England (most of the teams in the Football League were in the North and Midlands). Other teams they played in the Southern League included Tottenham Hotspur, Reading and Southampton.

No. 12 High Street, with a plaque recording its illustrious contribution to Portsmouth.

## DID YOU KNOW?

Portsmouth FC has always played at Fratton Park. Two new stands were added: one in the 1920s, the other in the 1930s. The earlier one was designed by the architect Archibald Leitch, a Glaswegian who designed stands for many major football grounds at the time, such as Liverpool's Anfield and Glasgow's Hampden Park. His stand originally included a clock tower and a pavilion.

Fratton Park.

# 11. Life in Portsmouth

## Beer

One of the benefits of the building of the new royal dockyard that began in 1495 was the construction of brewhouses. These were leased to private individuals on the condition that they would revert to royal use in time of war. By 1525, there were five of these brewhouses and their names still sound like good ones for pubs today – the Anchor, the Dragon, the Lion, the Rose and the White Hart. From our modern perspective, we might think this royal use in wartime rather odd – it conjures up pictures of drunken soldiers unable to fight the enemy – but, historically, beers and ales were often of lesser strength than today and played an important part in nutrition (upping the calorie count for one thing). Brewing also effectively sterilised the water used in it, making beers much safer to drink than ordinary water, which was often contaminated.

## DID YOU KNOW?

In 1858, the Borough of Portsmouth Water Works Co. took over the role of providing Portsmouth's water supply. Between 1858 and 1861, it spent over £50,000 in buying Havant Springs, 8 miles away, and building new pumping works. A new pumping station was built at Bedhampton later in the century.

Drinking continued to be very important to the town. In 1716, there were forty-nine public houses within the walls of what we now call Old Portsmouth, another forty-one within the much smaller area of Spice Island and another sixty-five scattered across Portsmouth Common and in outlying settlements such as Kingston. This gave a total of 155 on Portsea, while the total population of the island was probably less than 15,000 at this time. So, theoretically, there was roughly one pub for every 100 residents. However, a lot of the trade that kept these establishments in business came from the navy and crews of merchant vessels.

A Portsmouth trade directory for 1900 gives a list of brewers. Around a dozen of these appear to have working breweries within the Borough of Portsmouth. These are the ones I think are actually brewing here:

Mrs Ann Allen in Chapel Street, Landport.
Blake S. & T. N. & Co. Ltd, also in Landport.

Phenix Brewery, Collingwood Road, Southsea.

Long & Co. with their Southsea Brewery in Hambrook Street and St Paul's Brewery in King Street and Gloucester View, Southsea.

Lush & Co. Ltd, St George's Brewery, St George's Square, Portsea.

Mew W. B. Langton & Co. Ltd, No. 83 High Street, Portsmouth.

Pike, Spicer & Co. Ltd, Penny Street, Portsmouth.

The Portsmouth Brewery in Penny Street, with bonded stores in St Thomas Street.

Portsmouth United Breweries Ltd, Eldon Street, Southsea.

Roberts Frank, No. 5 Russell Street, Southsea.

Simonds H. & G. Ltd, No. 33 Marmion Road, Southsea.

Whicher Ernest George, No. 1 Queen Street, Portsea and Nos 45 and 46 Lion Street, Portsea (though their brewery may have been in Cosham).

Winchester Brewery Co. Ltd, Nos 69–75 Station Street, Landport.

In comparison, only one electrician is listed.

The Portsmouth Brewery in this list was better known as Brickwoods and was seen as the city's chief brewer for much of the twentieth century. The Brickwood family had been brewers in London since the late sixteenth century and, in the mid-nineteenth century, the Guildford branch of the family moved to Portsmouth. They moved premises several times and, by the time of the list, they were in the large premises in Old Portsmouth that is mentioned. The company sold out to Whitbreads in 1971 and the brewery was demolished a few years later.

## Fathers of the Famous
Much of Portsmouth's housing belonged to naval men, though since they were often away on long voyages for much of the time, often only their families lived there. It is noticeable when reading the biographies of famous people born in Portsmouth how many of them had fathers in or connected with the navy – we saw one example earlier in James Callaghan.

## A Prankster
Life in Portsmouth has always had its characters and little incidents. Here is one example, recorded in a local newspaper on 5 May 1800. Apparently, the bells of a house belonging to a Portsmouth resident called Mr Rood would ring loudly all day, to the general alarm of the household and neighbourhood. This was linked to occurrences at No. 15 Lombard Street (the street that runs off the High Street next to the cathedral) where a 'continued rapping' was heard, also at the house of a Mr Peake in the Dockyard, where 'continued groans appeared to issue from a large hollow tree near the house'.

The same account states that these things only took place when a servant girl who lived at all three properties was present. Although the newspaper account records all of this in a matter-of-fact manner, surely this has given the game away. It is very easy to picture the girl hiding in the hollow tree and sniggering to herself at the effect she is having.

## DID YOU KNOW?

The origin of the name 'Point' is pretty obvious when you look at a map of the area, but Spice Island is less so. Perhaps it came from the goods traded here, although it has also been suggested that the smell of the place in the days before modern drainage may have had something to do with it.

## DID YOU KNOW?

Spice Island long had a reputation for lawlessness and what people of the time called 'immoral behaviour'; it was outside the sixteenth century fortifications and so was more difficult to control. The presence of many pubs so close to the docks did not help matters. Perhaps only token efforts at stopping the bad behaviour and worse were made – some citizens may have felt that such behaviour was bound to happen in a port and were pleased it was not occurring near their own homes within the walls.

# 12. Miscellany

## A Colonial

The house where the Duke of Buckingham was assassinated was originally a tavern called the Spotted Dog. At the time of the murder it was the home of a sailor called Captain John Mason, who later became the founder of a colony in New England, though he died in 1635 before setting foot on it. The colony was named from Mason's starting point, which explains the name of the state of New Hampshire in the present-day United States.

## The Famous Font

Copnor's parish church, dedicated to the early British St Alban, was consecrated in 1914. As part of the celebrations, the church was presented with a font that had been used in St Mary's Church, Kingston, and it is still a prominent feature inside. Isambard Kingdom Brunel was baptised in this font in 1805, as was Charles Dickens seven years later.

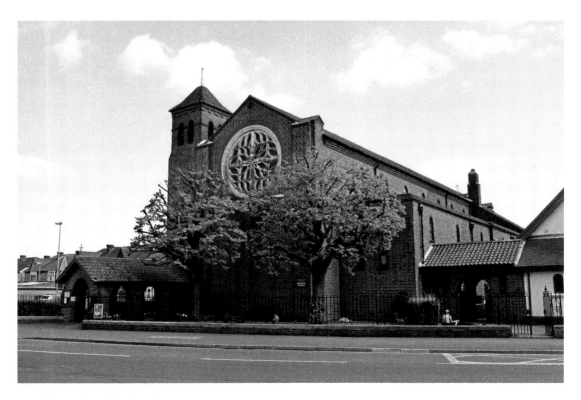

Copnor's parish church.

## Portsmouth's Canal

It may seem odd when it is surrounded by so much water, but a canal was once built across Portsea Island. The Napoleonic Wars of the late eighteenth and early nineteenth centuries had highlighted the vulnerability of seaborne traffic, so a plan was devised to allow smaller vessels at least to get between London and Portsmouth without having to venture into the open sea.

A vital part of this scheme was the Portsmouth and Arundel Canal. It is not clear exactly who designed this canal: two renowned engineers of the time, John Rennie and Josias Jessop, have been given the credit; they both worked on canals elsewhere in the British Isles. The resident engineer, who must have been on site all the time sorting out the details, was a James Hollinsworth.

The western part of its route entered Chichester Harbour then followed a 13-mile channel that had been dredged out, and which looped around the south of Thorney Island then passed to the north of Hayling Island before crossing Langstone Harbour.

The section across Portsea, sometimes called the Portsea Canal, opened in the early 1820s. It ran from Eastney Lake, the inlet at the south-west corner of Langstone Harbour across the southern part of the island, to end at a basin conveniently located for the naval dockyard and commercial port.

It was a nice idea, but in 1827 the Portsea Canal had to be drained because the seawater that filled it was soaking through the canal's lining and contaminating local wells. Parts of the larger canal system silted up and had to be abandoned, and increasing competition from the new railways can hardly have helped. Although tolls were reduced to encourage its use, the canal was closed in 1855. Any vessels that would have used it were now diverted to Portsmouth through Ports Creek.

Most of the Portsea Canal was filled in afterwards. Today, Goldsmith Avenue runs along much of the eastern end of the route as far as Fratton railway station, and the railway line itself follows more of it as it heads towards the main station. The stone-lined basin at the canal's terminus is now completely unrecognisable – the Arundel Shopping Centre in Arundel Street to the north-west of the main railway station sits on it.

Looking out towards Eastney Lake from the footbridge across the sea-lock at Milton.

The adjacent boat storage area.

There is one part of the Portsea Canal that you can still see today. In Milton, Locksway Road (there's a clue in the name) and a footpath take you down to the sea lock at the Langstone Harbour end of the canal. A footbridge crosses the lock and, looking seaward from it, you see the brick-lined channel projecting into the harbour. In the other direction there is a small area used to store boats, then the channel is infilled. A second lock that was a short distance inland by the Oyster House pub has been demolished.

## Railway Oddities

The original plans for the railway into Portsmouth included a station at Copnor, which would have been an ideal location to serve the expanding northern suburbs. The station itself was never built, but its access road was – well, almost. Station Road leaves Copnor Road not far south of the parish church and takes a somewhat winding route towards the railway but, since there is no station for it to serve, it finishes at a dead end close to the railway line.

For around thirty years, Southsea had its own railway branch line named the Southsea Railway. This opened in 1885 and was only a mile and a quarter long. The branch left the main line at Fratton Station and curved slightly eastwards as it headed south to a terminus near what is now a roundabout at the western end of Granada Road. In 1903,

Proof that I wasn't making it up about there being a Station Road in Copnor.

the locomotive-pulled trains were replaced by a steam railcar and, the following year, two intermediate halts were added at Jessie Road and Albert Road. In its latter years the line was losing out to competition from trams. So, when, just after the outbreak of the First World War in 1914, the government announced that lines that were unable to pay for themselves were to cease operations, the branch closed. Since built over, you can still make out the route on a map – Francis Avenue and Heidelberg Road which curve off Goldsmith Road on the south-east side of Fratton station are following it roughly, then Bath Road does the same.

## DID YOU KNOW?

The original railway line to Portsmouth, built in the 1850s, ended at the main railway station (Portsmouth and Southsea). Portsmouth Harbour station is at the end of an extension to the line that was added in 1876. If you look across at this station from the Hard, you will see that it is built on wooden piles and extends into the harbour, allowing for easier access to passenger ships.

# Bibliography

In writing this book, I used a number of internet sites as sources of information that are too many to list here, but I must mention the value of the British Listed Buildings website (http://www.britishlistedbuildings.co.uk) for details of particular buildings. I also used the following books:

Anon, *A Guide Book Through The Royal Dock-Yard and Naval Establishments of Portsmouth* (Henry Lewis: Portsmouth, 1854).

Bardell, M., *Portsmouth: History and Guide* (Tempus Publishing: Stroud, 2001).

Conan Doyle, Sir Arthur, *A Study in Scarlet* (1887; Penguin Pocket Classics: 2007).

Conan Doyle, Sir Arthur, *The Sign of Four* (1890; Penguin Pocket Classics: 2010).

Gates, W. G., *Portsmouth through the Centuries* (unbound copy in Portsmouth Library, 1931).

Hardy, T., *Life's Little Ironies* (1894; 1995).

*Kelly's Directory of Portsmouth, Portsea, Landport, Southsea and Suburbs for 1900* (London, Kelly's Directories Limited: 1900).

Sadden, J., *Portsmouth: A Pocket Miscellany* (The History Press: Stroud, 2012).

Smith J., *The Book of Hilsea: Gateway to Portsmouth* (Halsgrove: Tiverton, 2002).

Victoria County History, 'The liberty of Portsmouth and Portsea Island: Introduction', in *A History of the County of Hampshire: Volume 3*, ed. William Page (London, 1908).

Wallis, S., *Literary Portsmouth* (Amberley Publishing: Stroud, 2013).

# Acknowledgements

Portsmouth History Centre in the Central Library provided invaluable material. I also found lots of useful information in Portsmouth City Museum. My thanks also to the many organisations that erected the interpretation boards that are dotted around the area – these helped me find my way around and again provided much interest.